In Art: New York City

{Enjoying Great Art Series}

Brought to you by

Catherine McGrew Jaime

Books in the "Enjoying Great Art" Series by Catherine Jaime:
- *In Art: Animals*
- *In Art: Books*
- *In Art: Bridges*
- *In Art: Candlelight*
- *In Art: Cats*
- *In Art: Christmas*
- *In Art: Eagles*
- *In Art: Food*
- *In Art: Hats*
- *In Art: Horses*
- *In Art: India*
- *In Art: Leonardo*
- *In Art: Lighthouses*
- *In Art: Maps & Globes*
- *In Art: Military*
- *In Art: Necklaces*
- *In Art: New York City*
- *In Art: Pastimes*
- *In Art: Self-Portraits*
- *In Art: Scions of Africa*
- *In Art: Shakespeare*
- *In Art: Trains*
- *In Art: Trees*
- *In Art: Turkey*
- *In Art: Parasols and Umbrellas*
- *In Art: U.S. Government*
- *In Art: U.S. States*
- *In Art: Venice*

Book in the series by Bonnie Hardison
- *In Art: Girls with Flowers*
- *In Art: Flowers*
- *In Art: Knights*

Books in the series by Deirdre Fuller:
- *In Art: America's National Parks*
- *In Art: Art*
- *In Art: Birds*
- *In Art: Butterflies*
- *In Art: Chairs*
- *In Art: Chickens*
- *In Art: Churches*
- *In Art: Clowns*
- *In Art: Dogs*
- *In Art: Donkeys*
- *In Art: Elephants*
- *In Art: Farming*
- *In Art: Pugs*
- *In Art: Sheep*
- *In Art: Shoes*
- *In Art: U.S. Presidents*
- *In Art: Winter*

Pictures used with Permission from the following Dover clip art books:

- *60 Great Travel Posters*
- *120 Great American Paintings*
- *120 Great Impressionist Paintings*
- *120 Great Paintings*
- *120 Great Travel Poster*
- *Old-Time American Cities and Sights*
- Vintage New York City Views

Copyright © 2014 by Catherine McGrew Jaime
www.CatherineJaime.com

Creative Learning Connection
8006 Old Madison Pike, Ste 11-A
Madison, AL 35758
www.CreativeLearningConnection.com

> *"One can't paint New York City as it is, but rather as it is felt."*
>
> Georgia O'Keeffe

When I think of cities in the United States, I think first of New York City – it has been a part of American history from before we became a country. But until recently I hadn't realized how many times it appeared in paintings through the centuries.

This small book takes a quick look at New York City through art. It is meant to be enjoyed by adults and students of all ages.

Look through these paintings that span many decades, and notice the similarities and the differences between them…See the colors, the textures and patterns, and more. Take note of whether there are people included in the different paintings; and if so, are men, women, or children more often portrayed? Do you like certain artists or styles more than others?

But, most of all, enjoy!

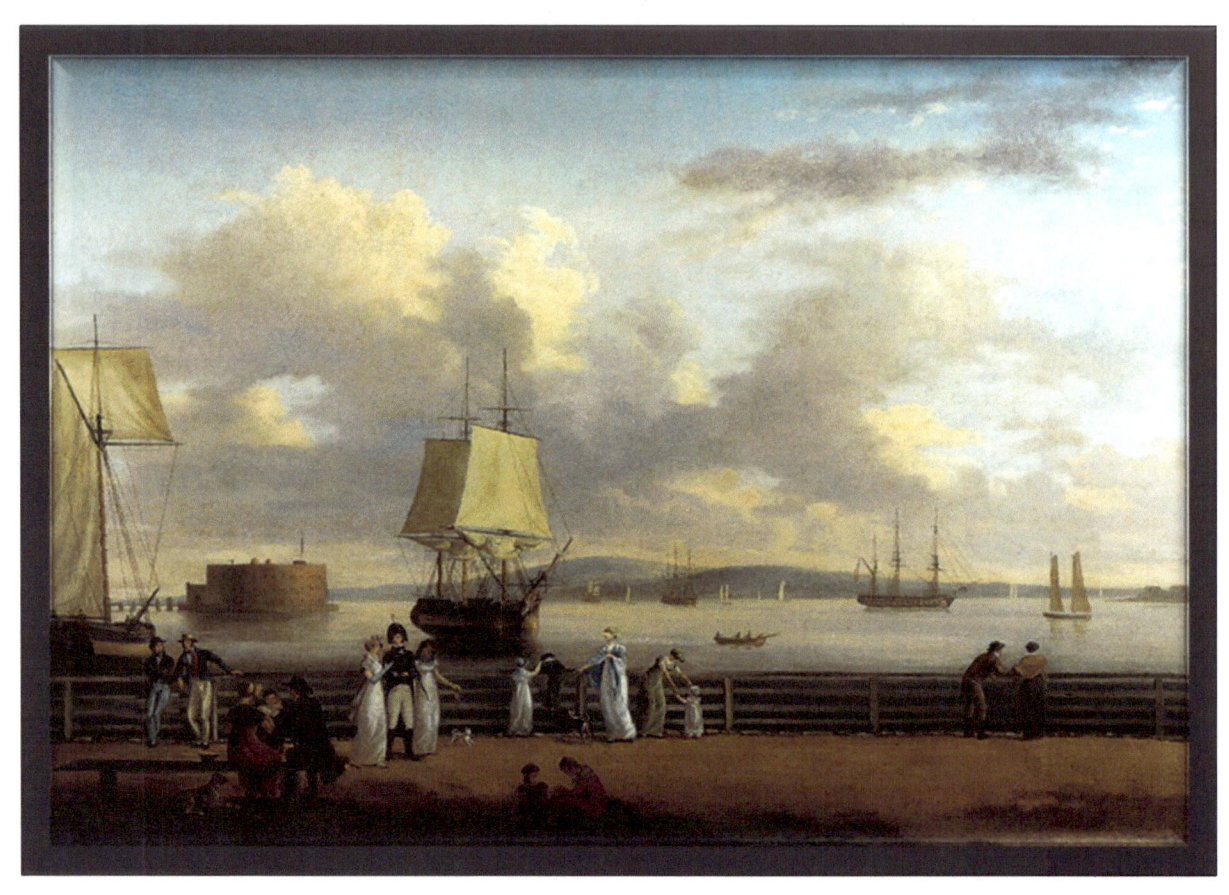

The Battery and Harbor

Thomas Birch, 1811

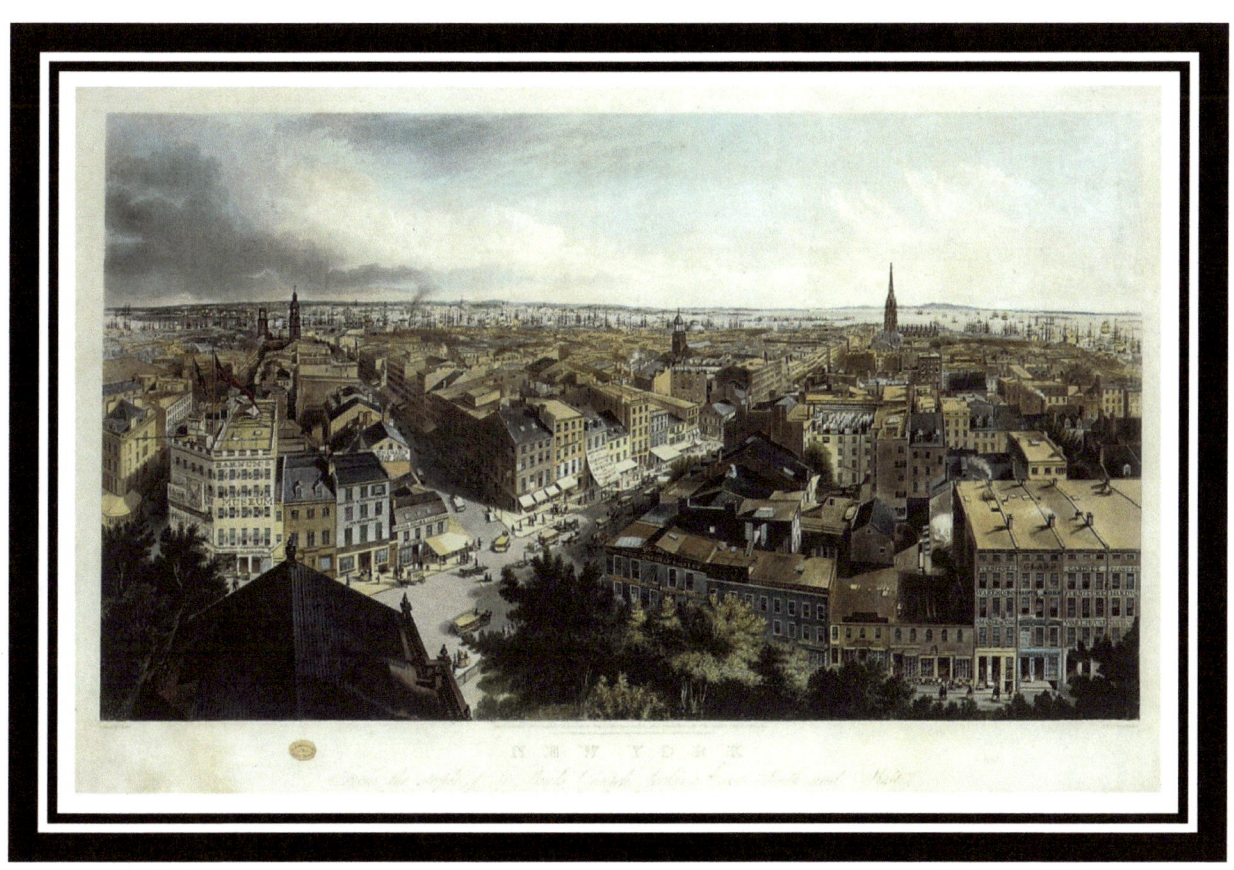

New York from the Steeple of Saint Paul's Church Looking East, South, and West

Henry Papprill, 1848

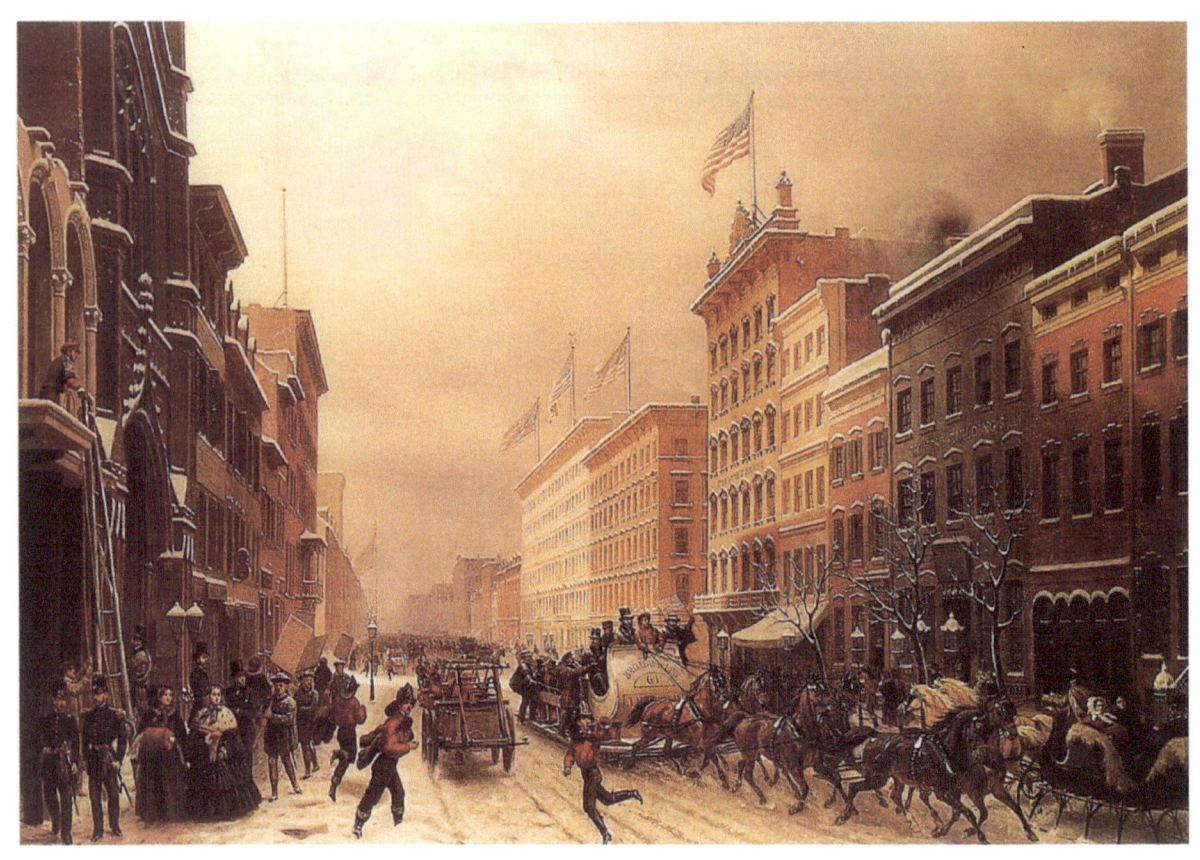

Broadway at Spring Street

Hippolyte Sebron, 1855

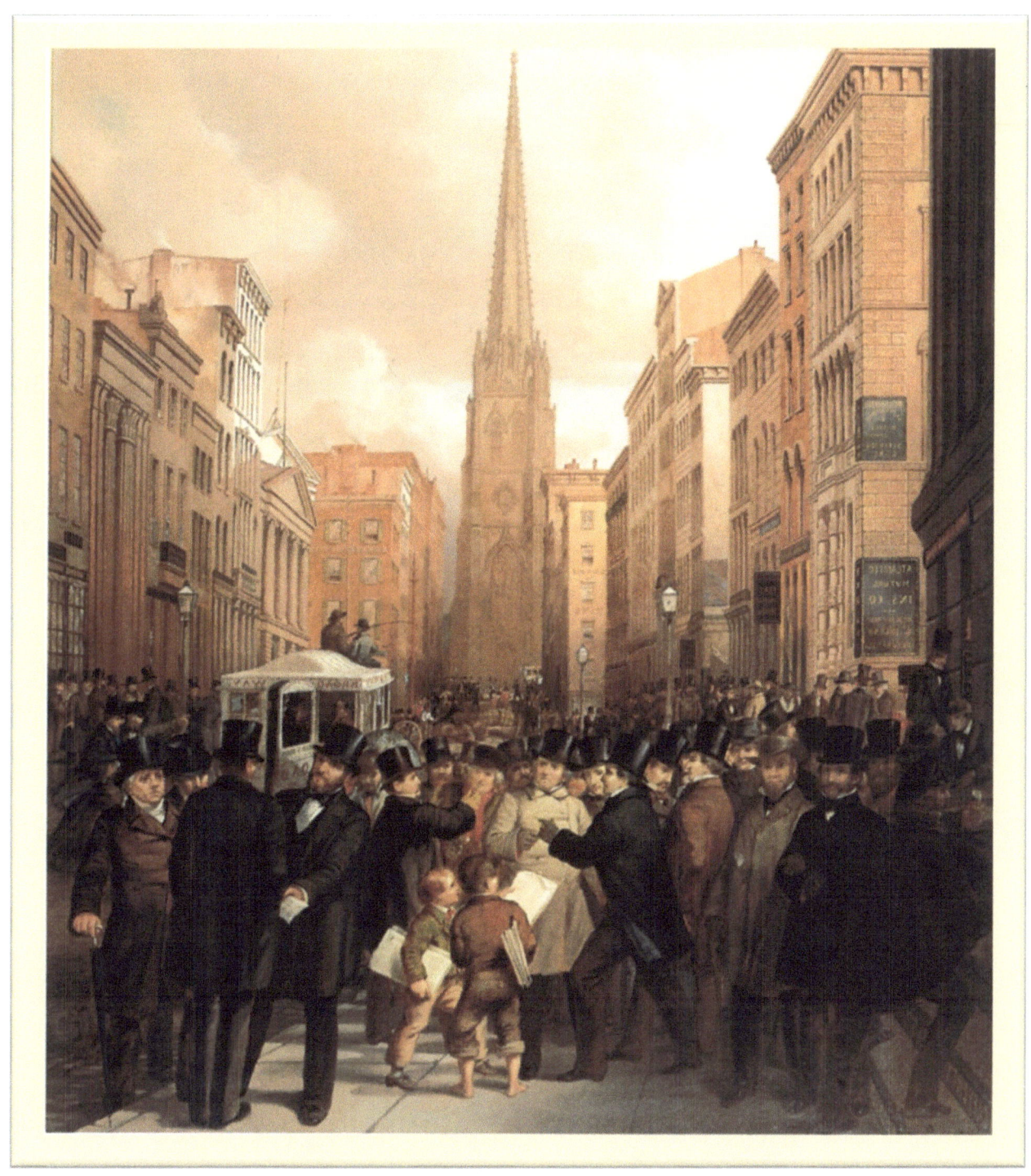

Wall Street, Half Past Two O'Clock, October 13, 1857

James Cafferty and Charles G. Rosenberg, 1858

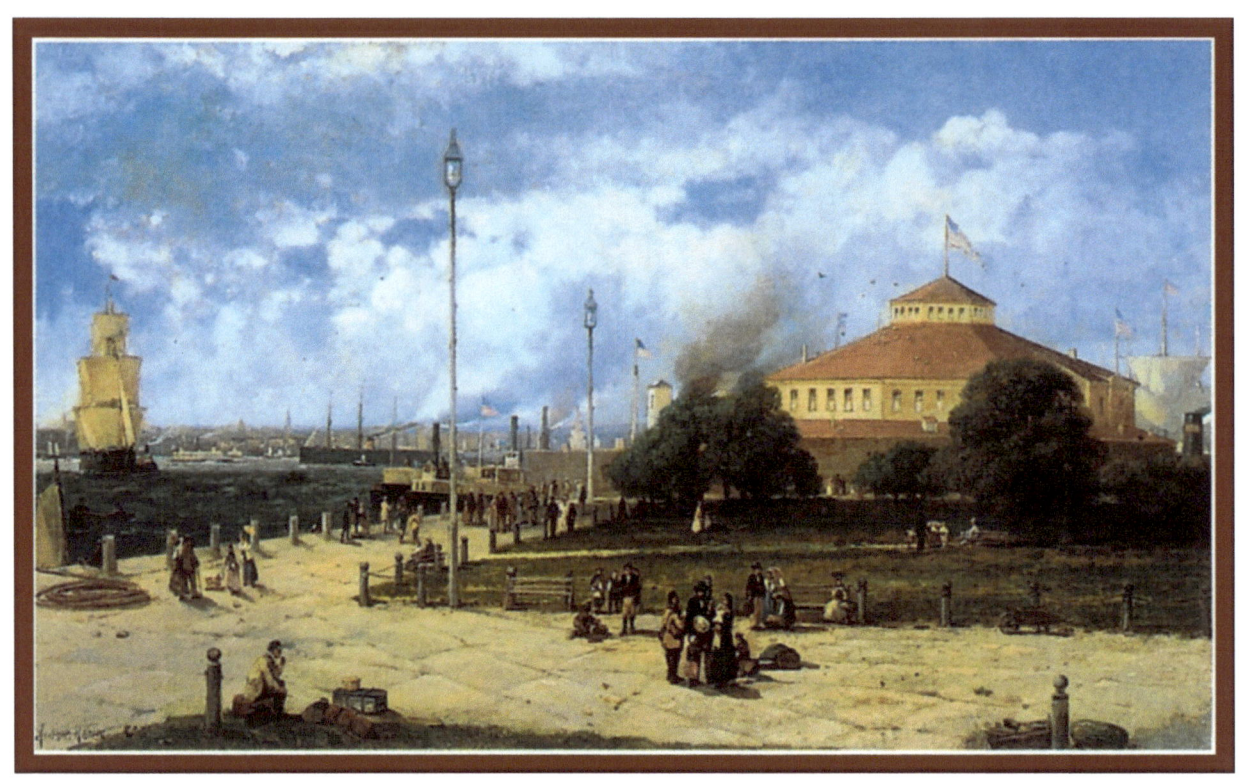

New York Harbor and Battery

Andrew Melrose, 1885

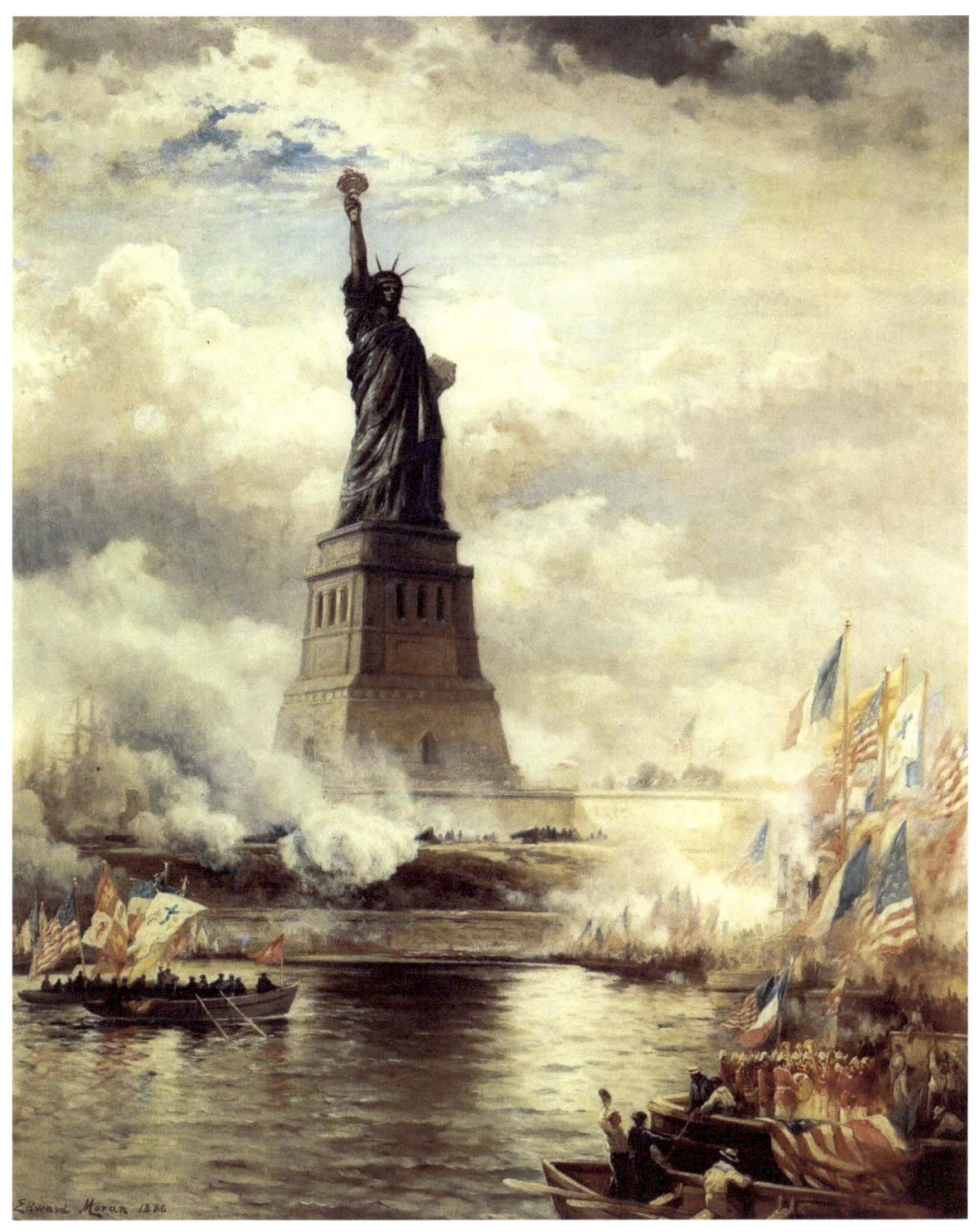

Statue of Liberty Enlightening the World

Edward P. Moran, 1886

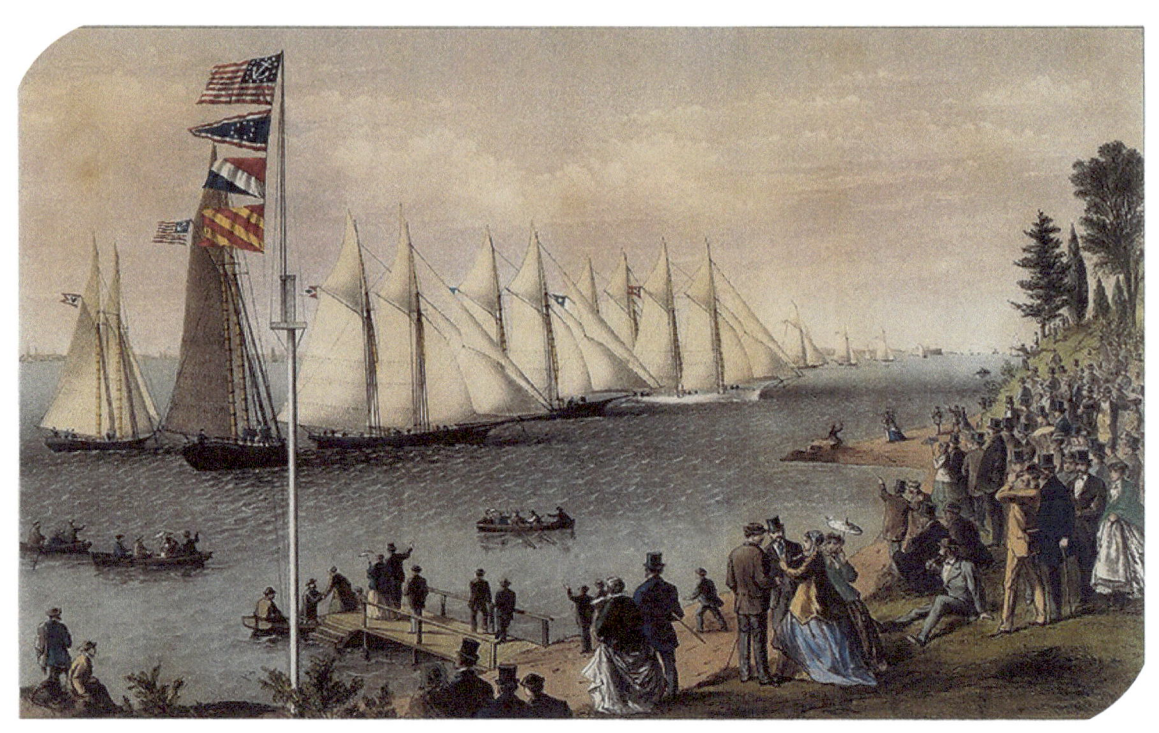

The New York Yacht Club Regatta

Charles Parsons and Lyman Atwater, 1869

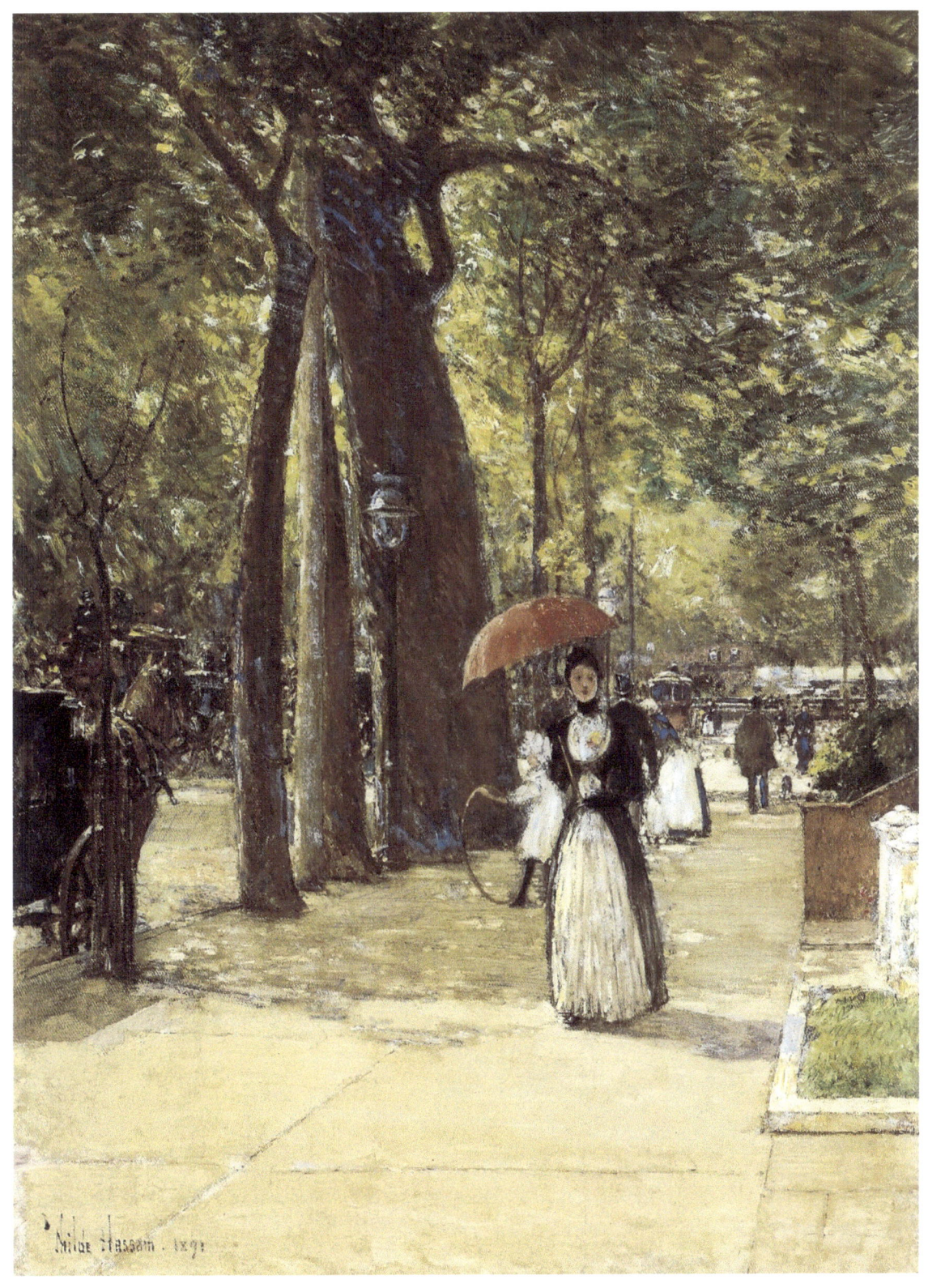

Fifth Avenue at Washington Square

Childe Hassam, 1891

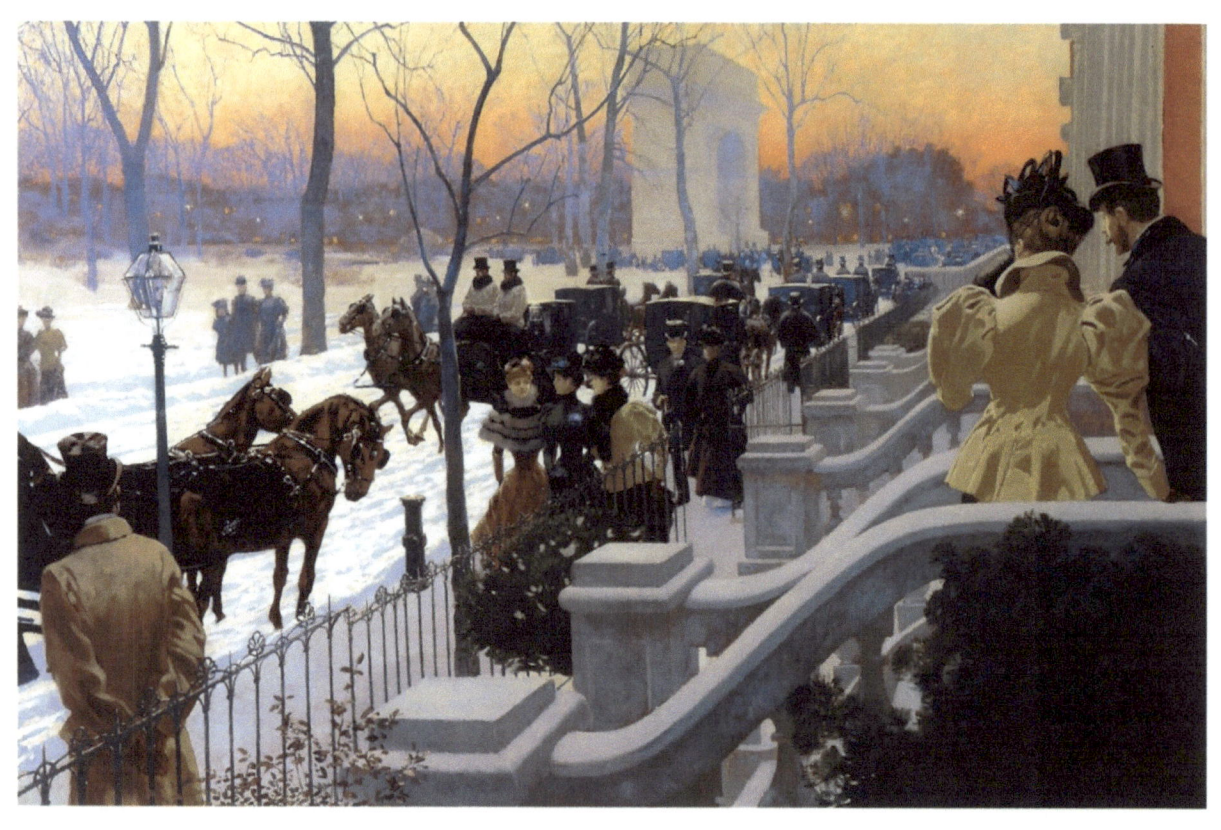

A Winter Wedding – Washington Square

Fernand Lungreen, 1897

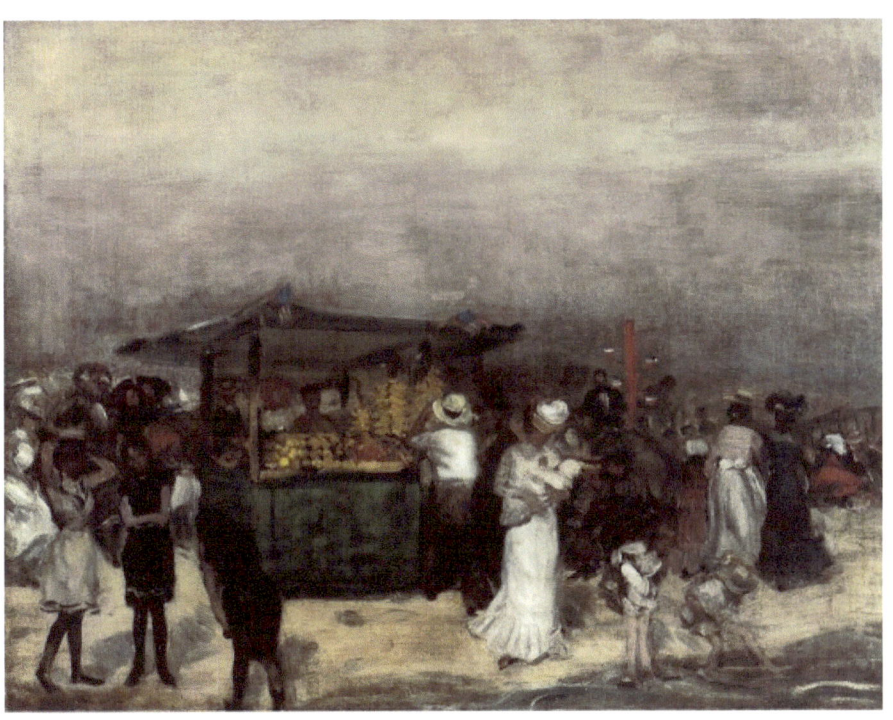

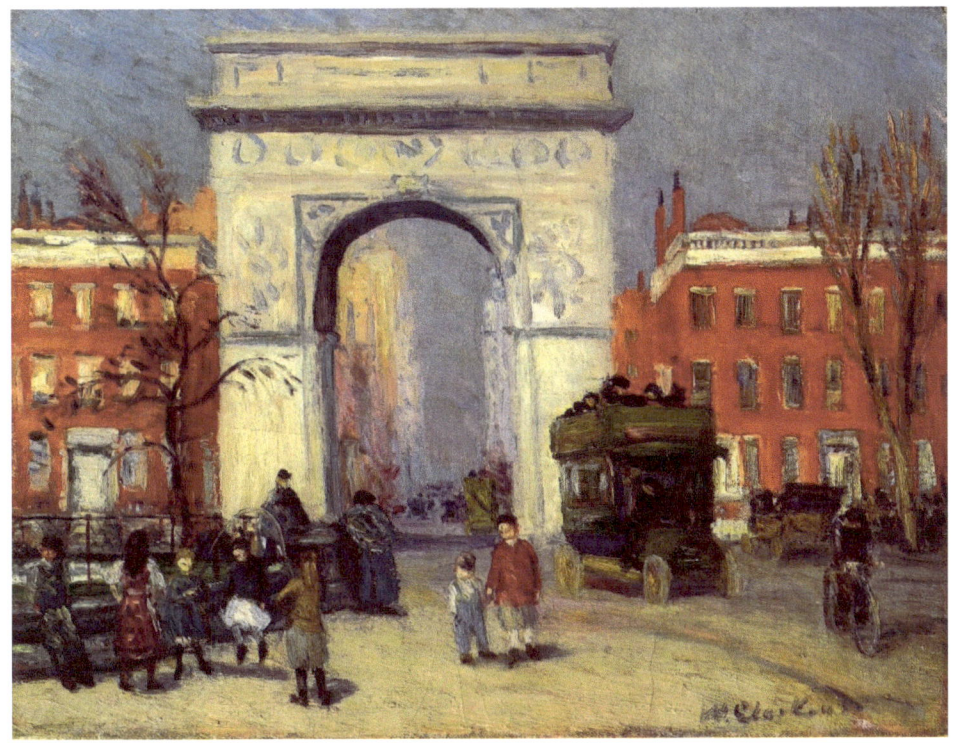

Above: Fruit Stand Coney Island

Below: Washington Square Park

William Glackens, 1898 & 1908

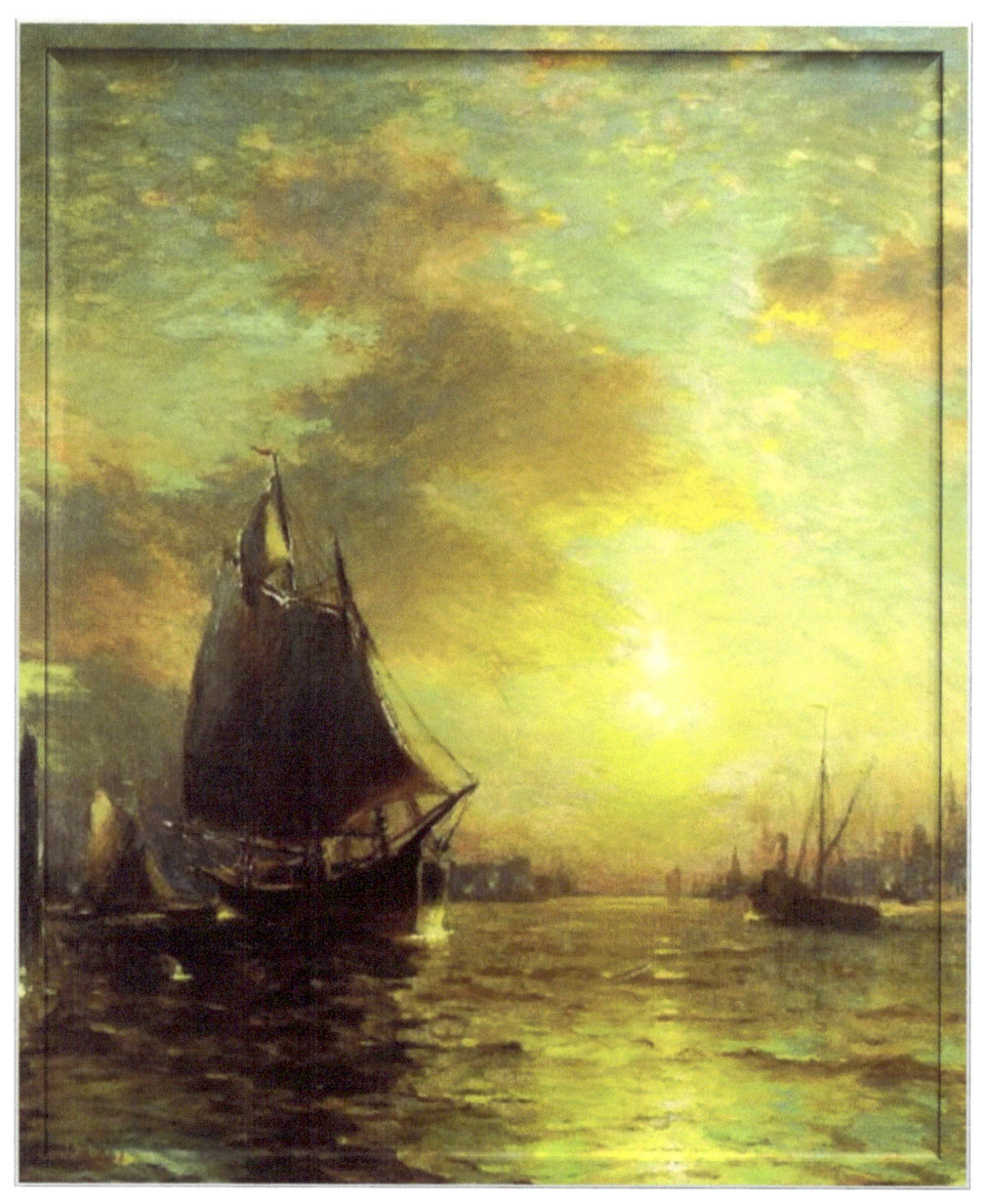

New York Harbor

George Herbert McCord, c.1899

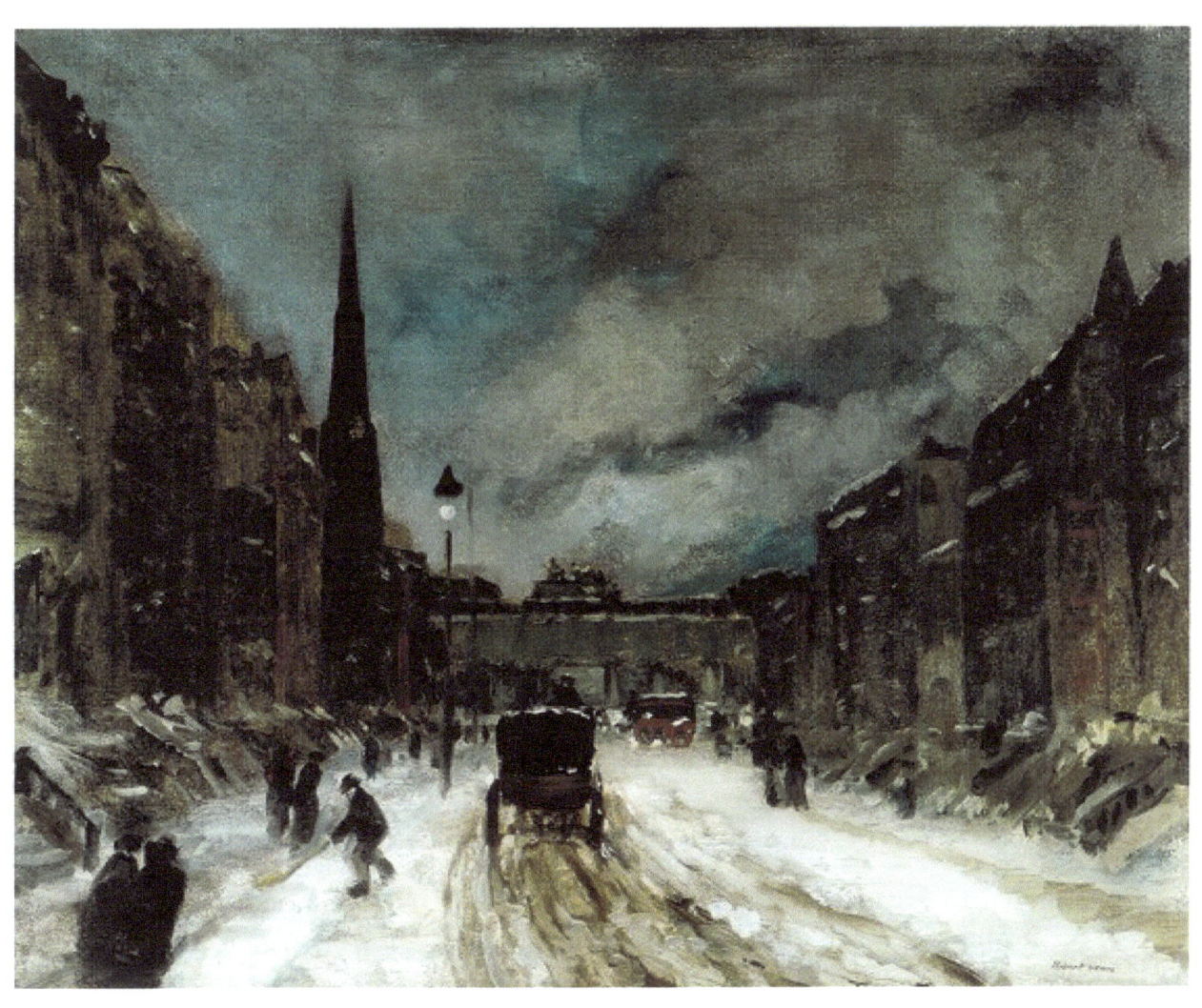

Street Scene with Snow (57th Street)

Robert Henri, 1902

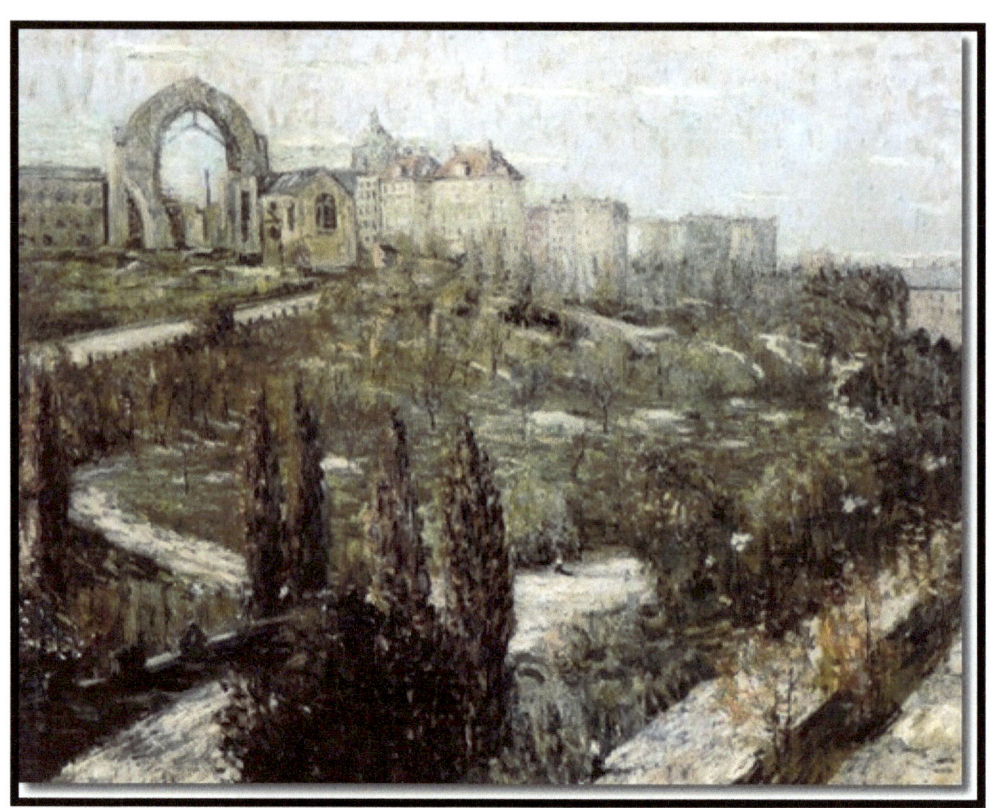

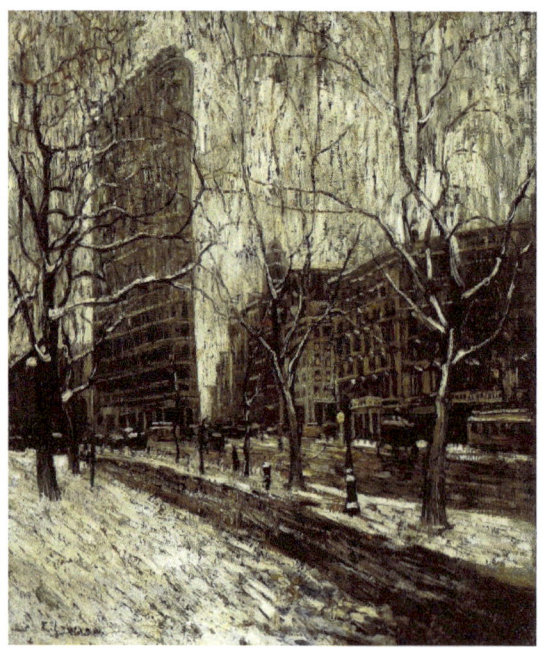

Above: Morningside Heights

Below: The Flatiron Building

Both: Ernest Lawson, 1902 - 1905

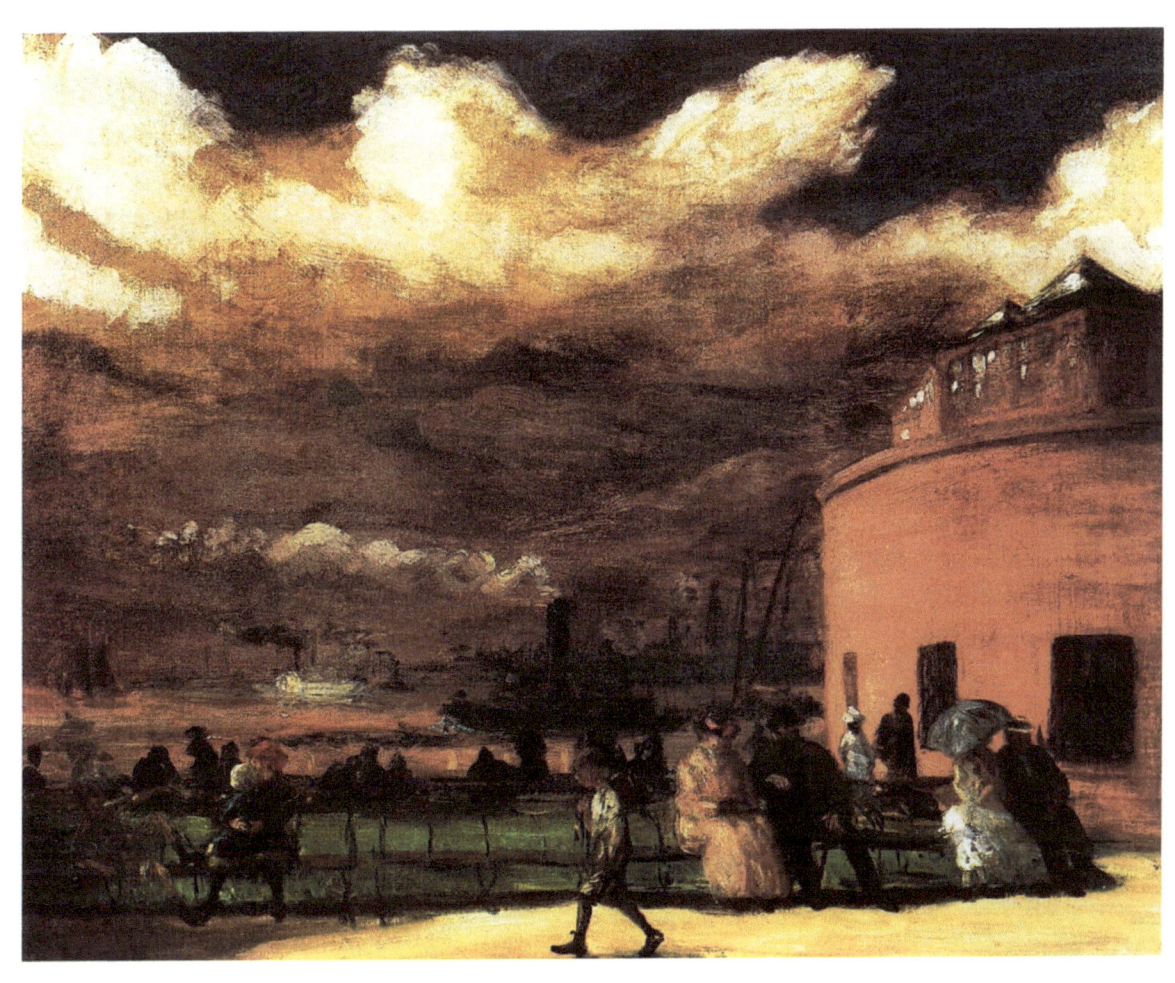

Battery Park

William Glackens, 1902 - 1904

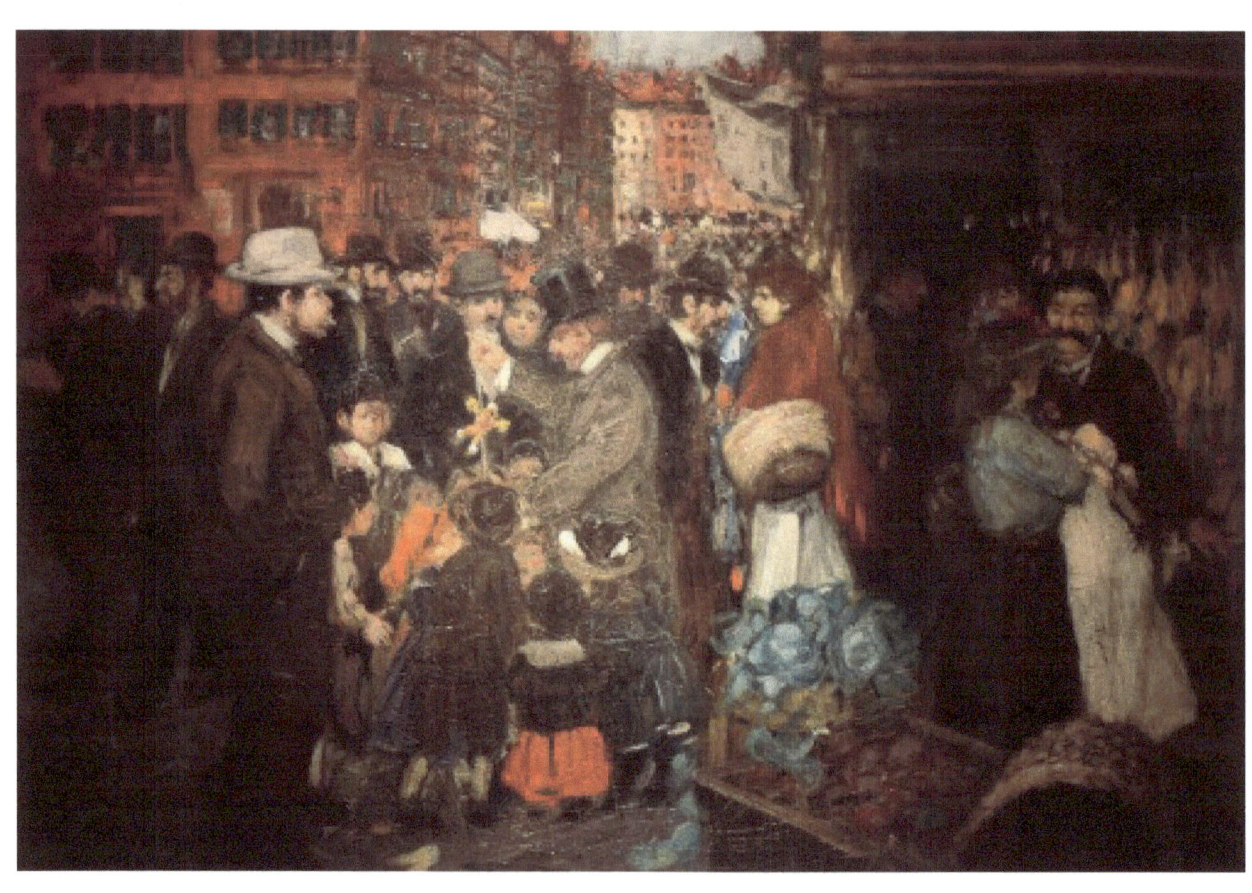

Street Scene (Hester Street)

George Luks, 1905

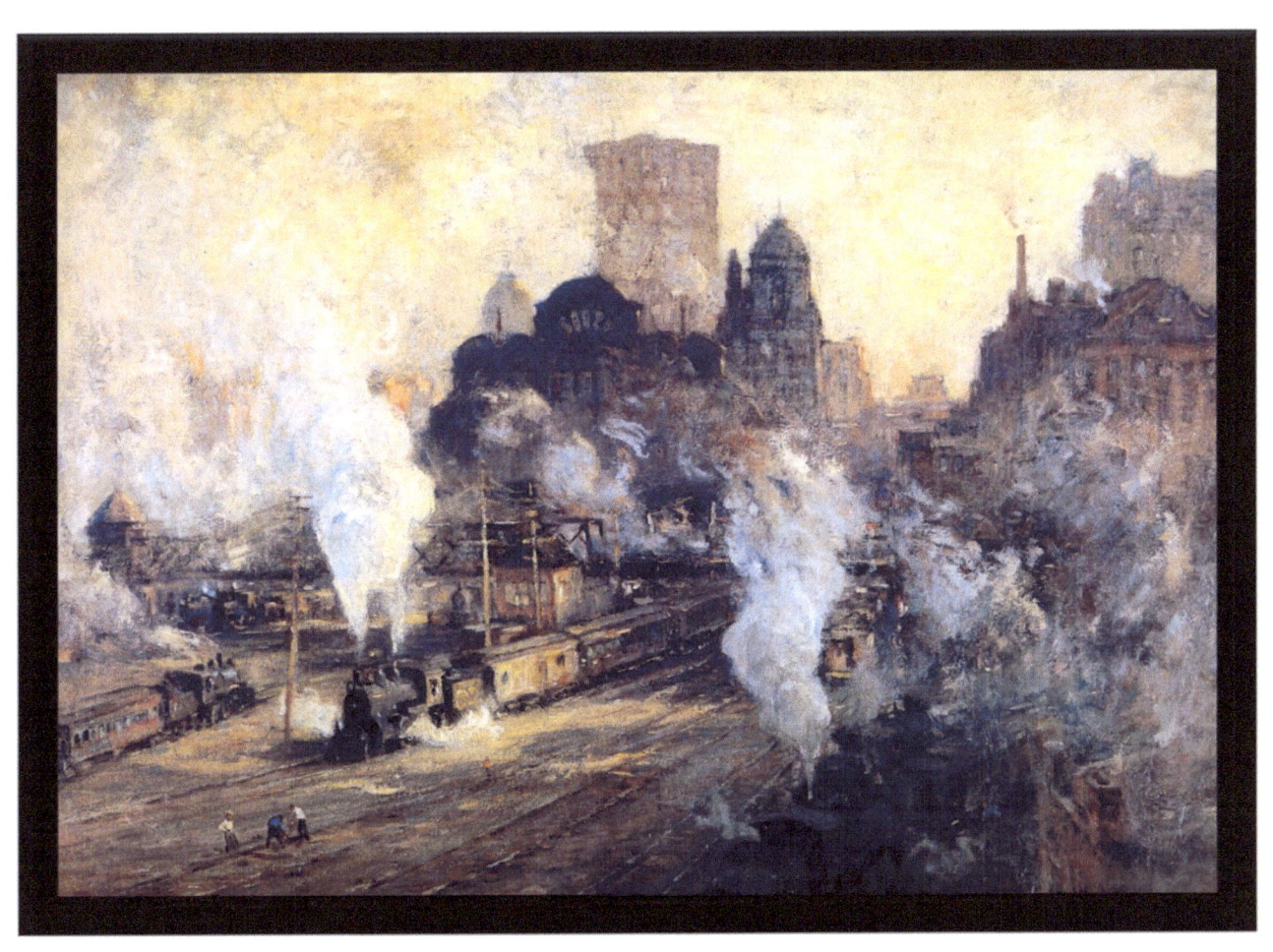

Old Grand Central Station

Colin Campbell Cooper, 1906

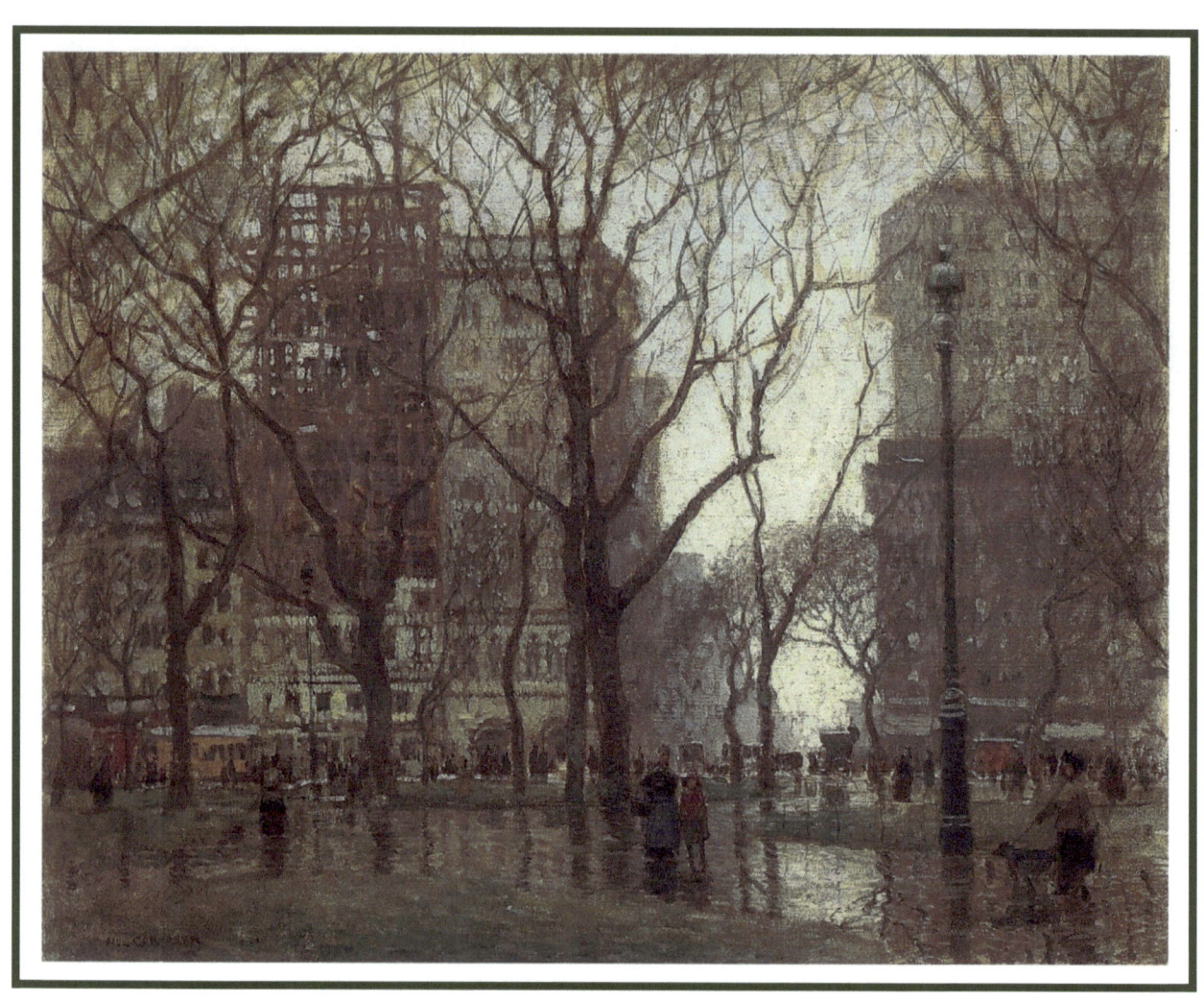

Rainy Day, Madison Square

Paul Cornoyer, 1907 – 1908

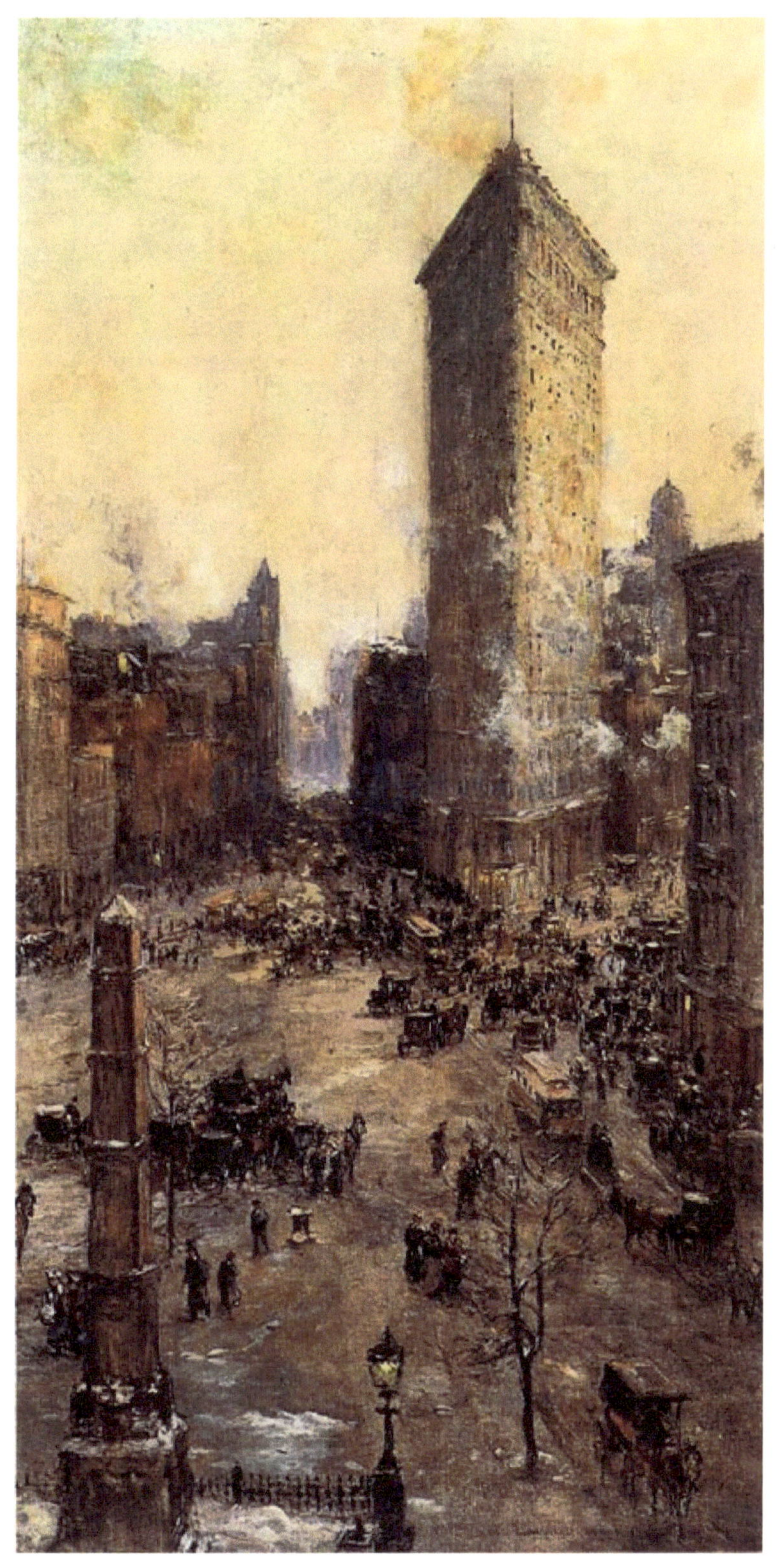

Flat Iron Building

Colin Campbell Cooper, 1908

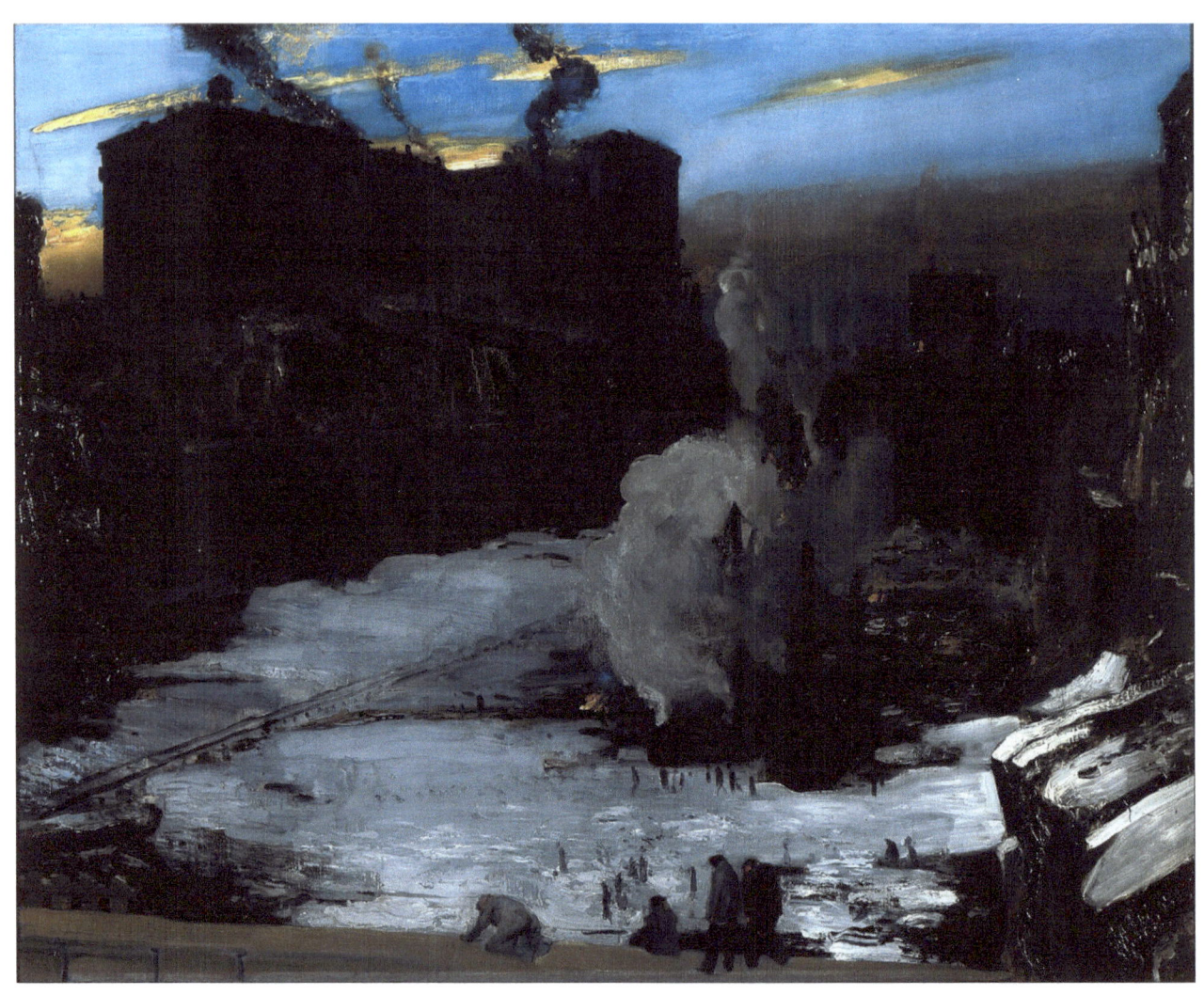

Pennsylvania Station Excavation

George Wesley Bellows, c.1908

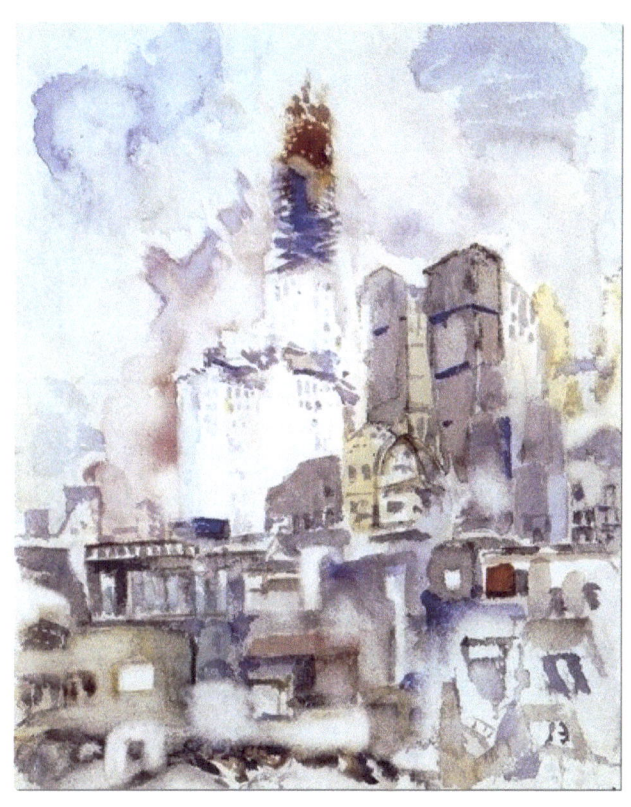

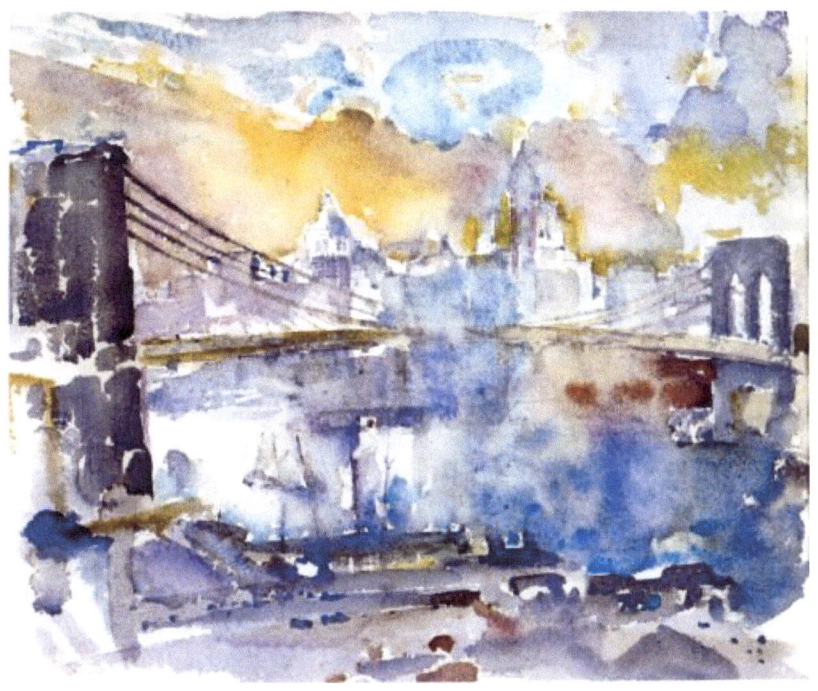

Above: Woolworth Bridge Under Construction

Below: Brooklyn Bridge

Both: John Marin, 1911 & 1912

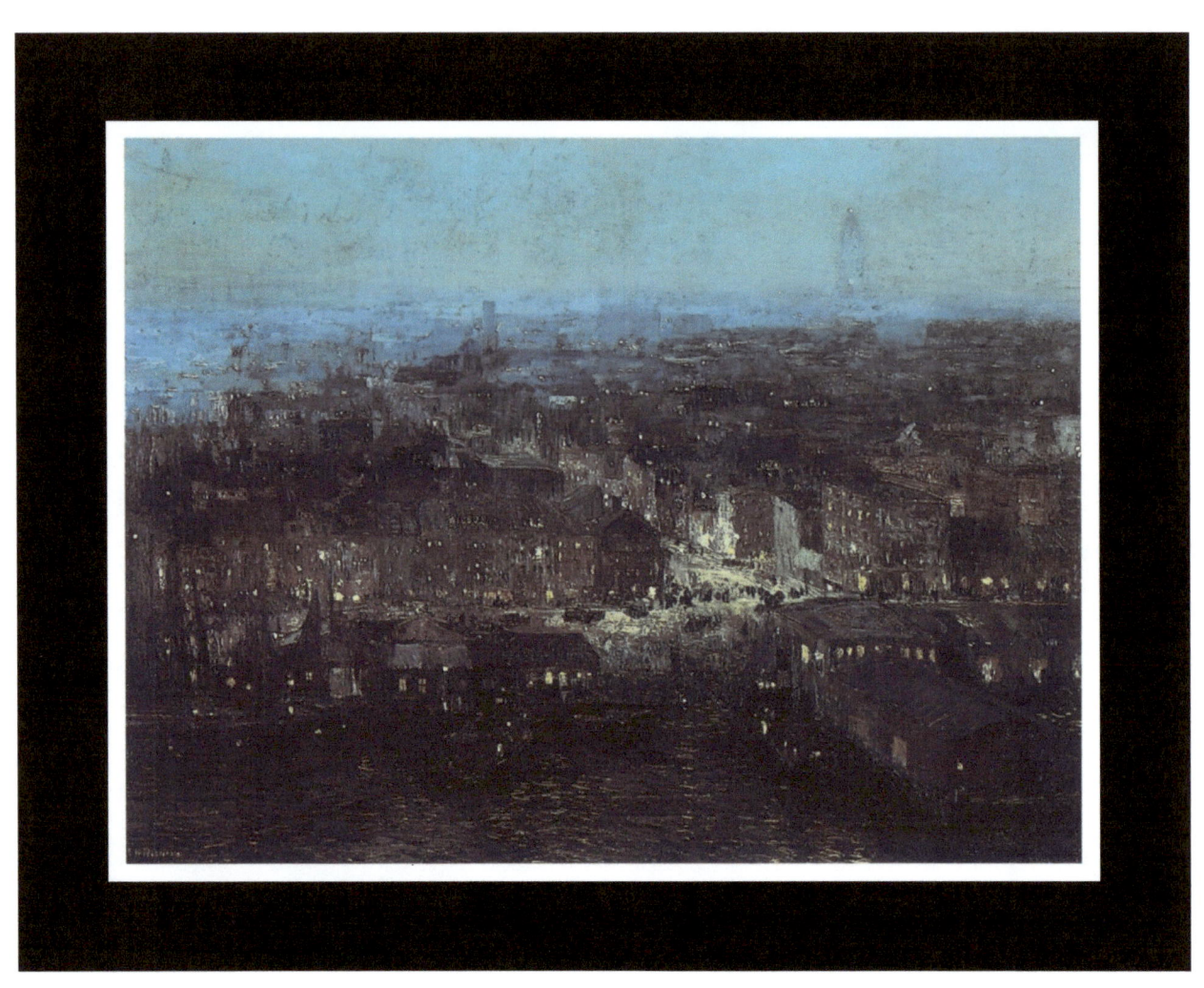

Lower New York

Edward Redfield, 1910

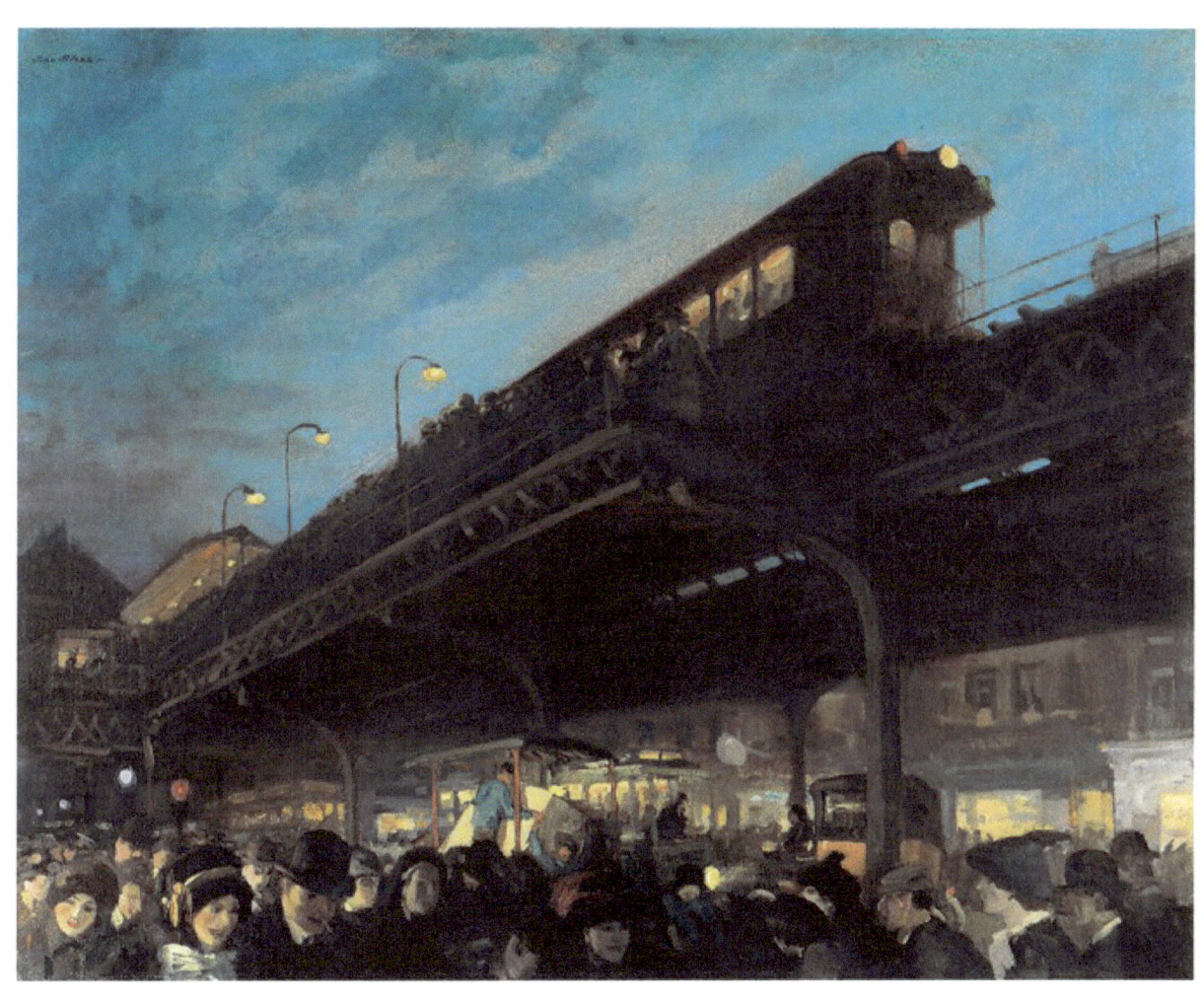

Six O'Clock

John Sloan, 1912

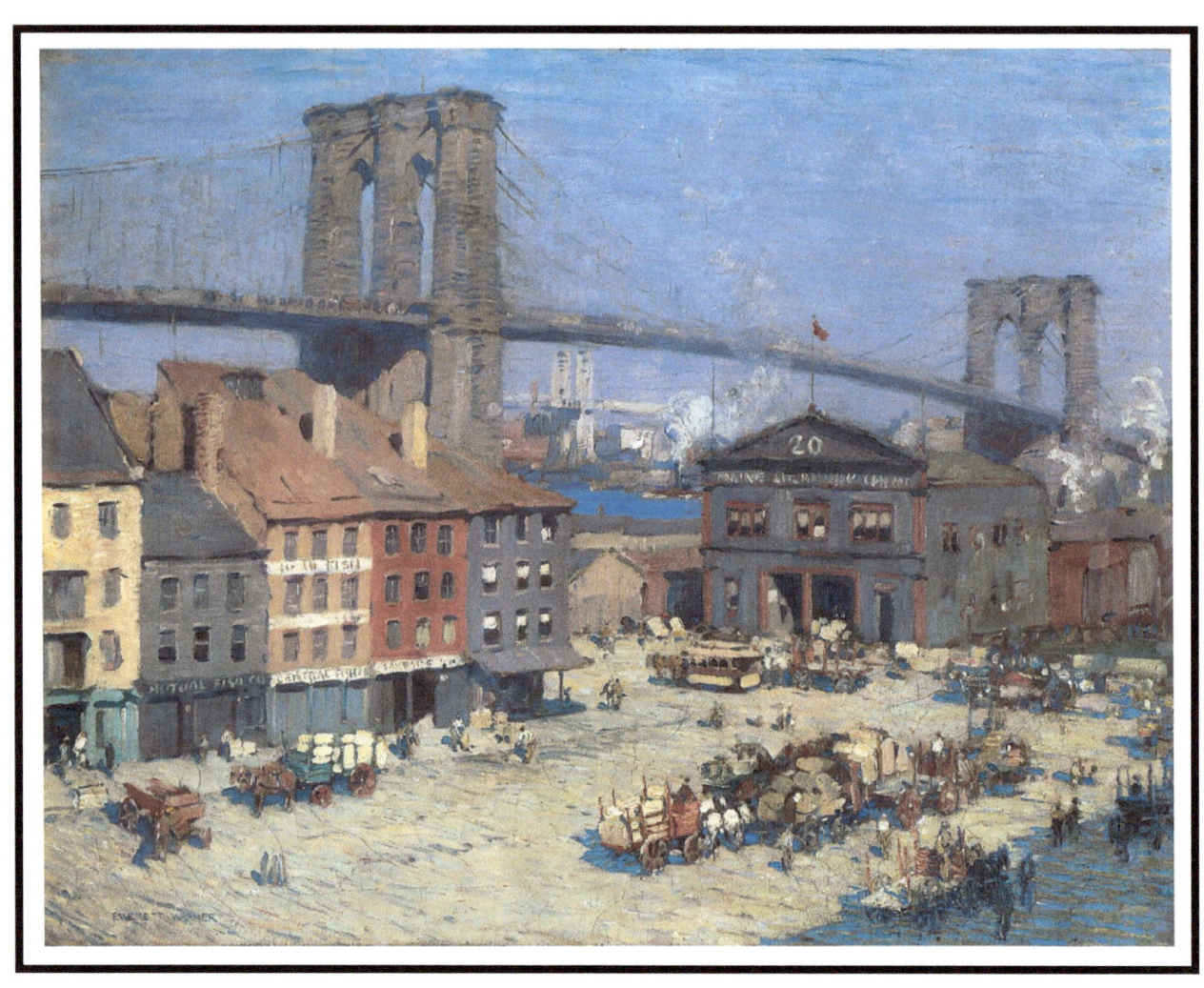

Along the River Front, New York

Everett Longley Warner, 1912

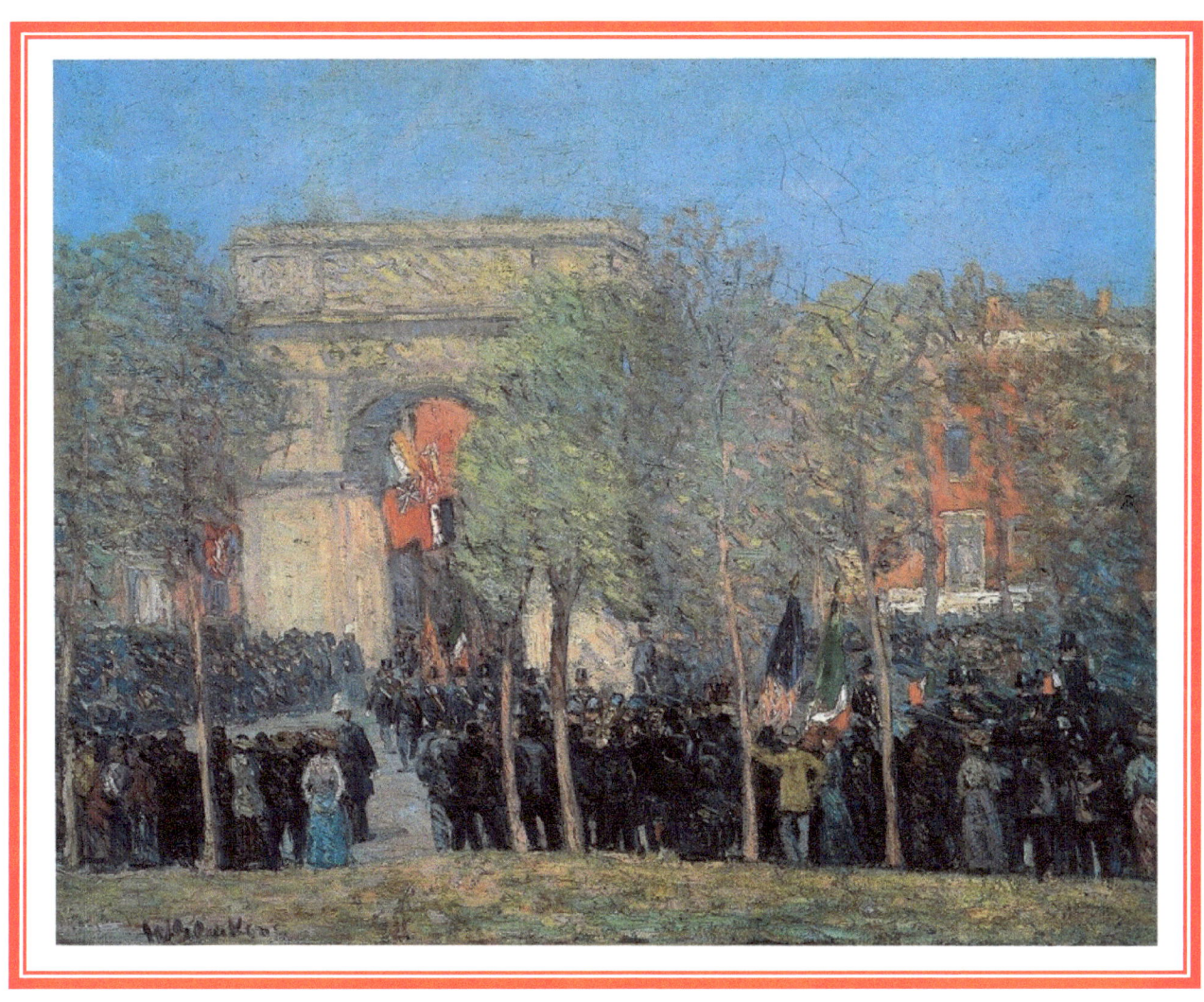

Italo-American Celebration, Washington Square

William Glackens, 1912

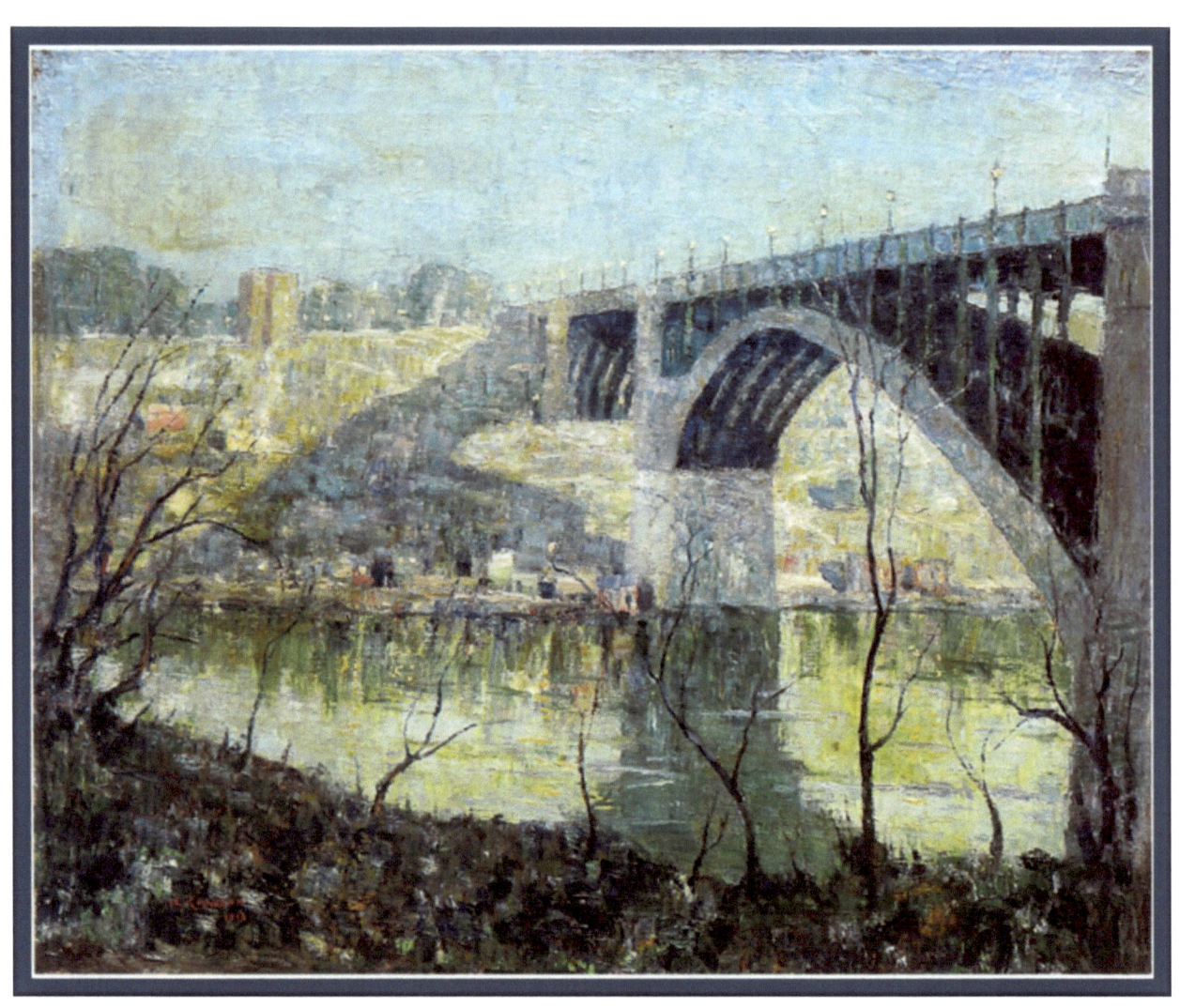

Spring Night, Harlem River

Ernest Lawson, 1913

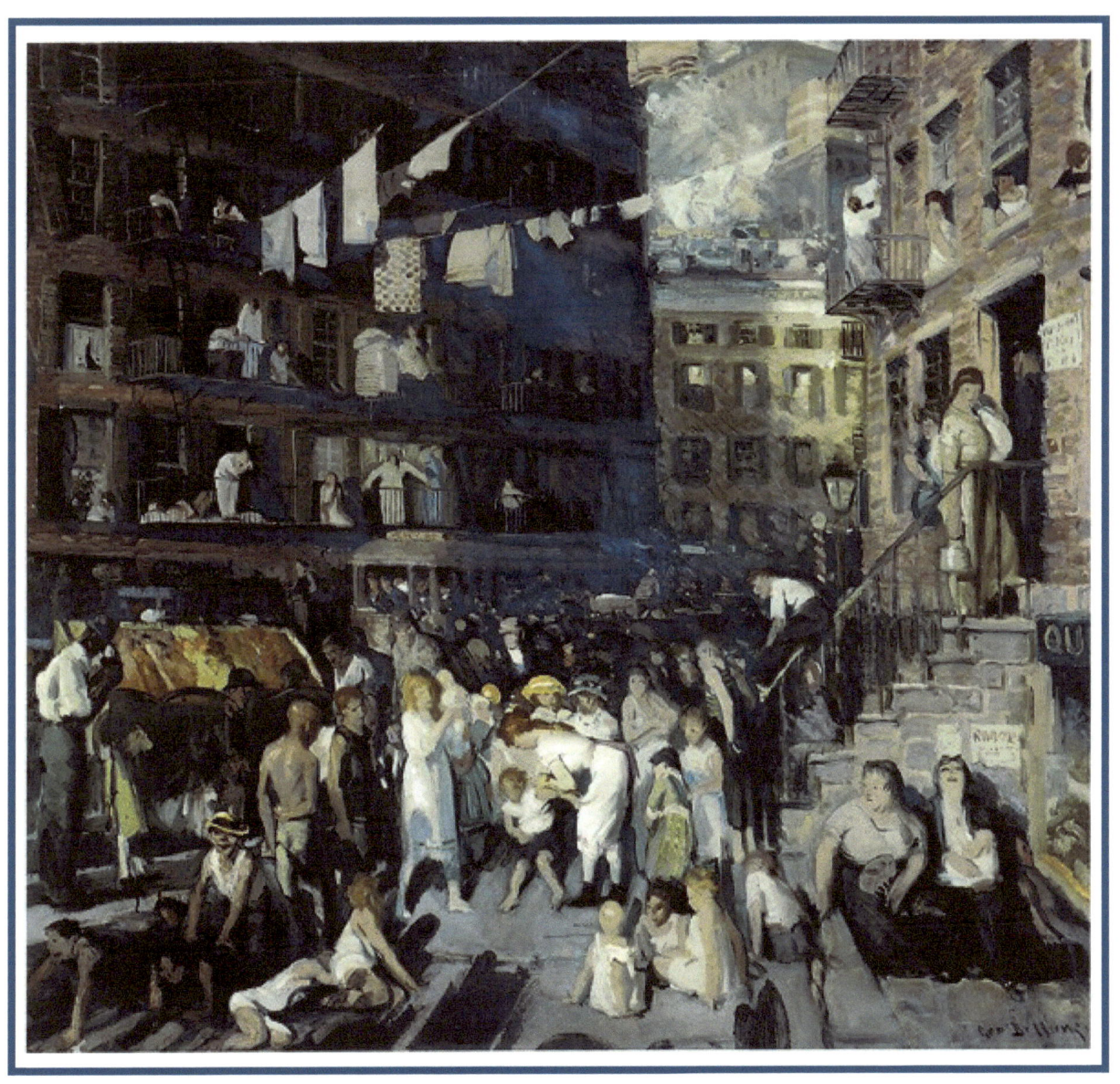

Cliff Dwellers (Lower East Side)

George Bellows, 1913

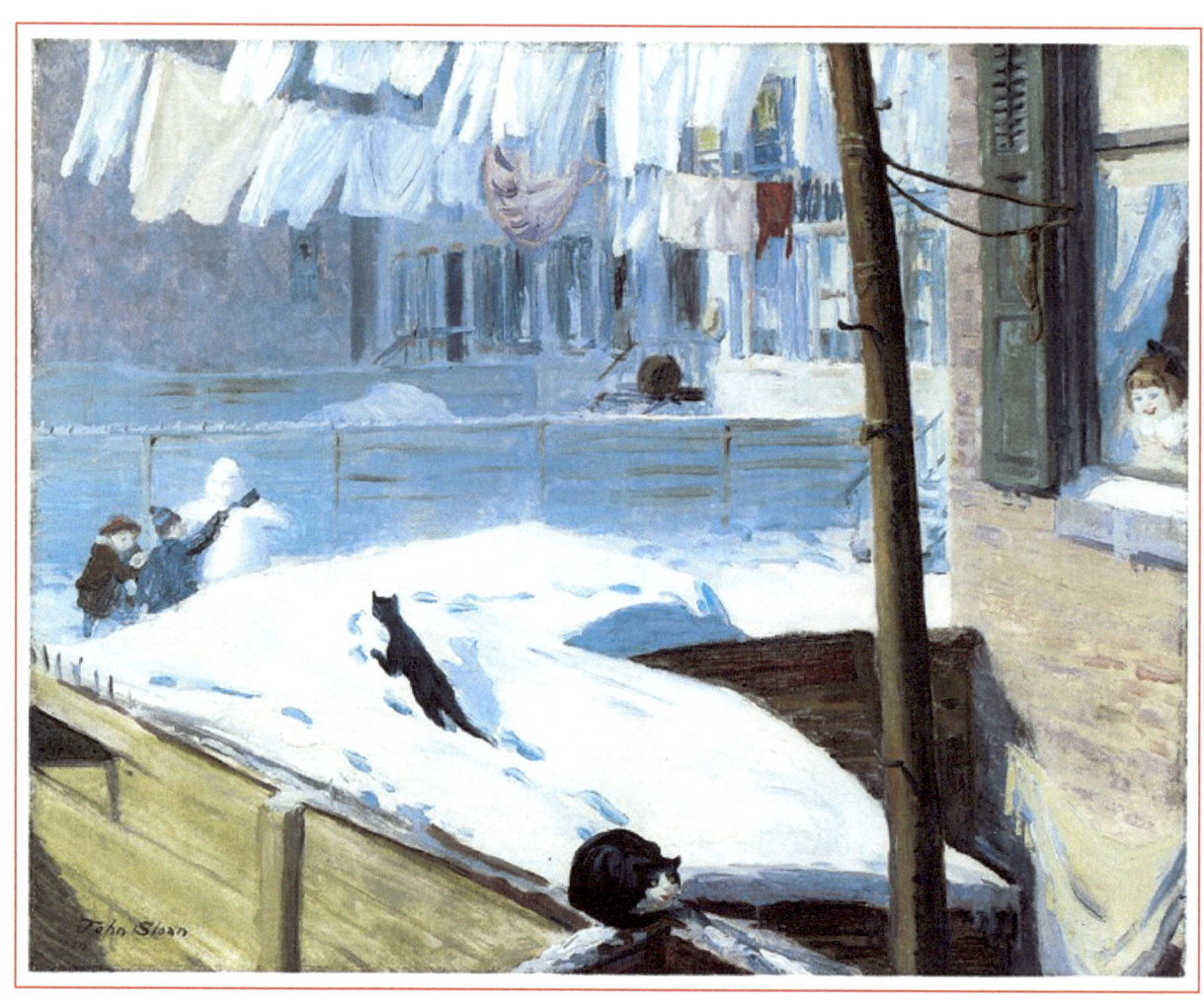

Backyards, Greenwich Village

John Sloan, 1914

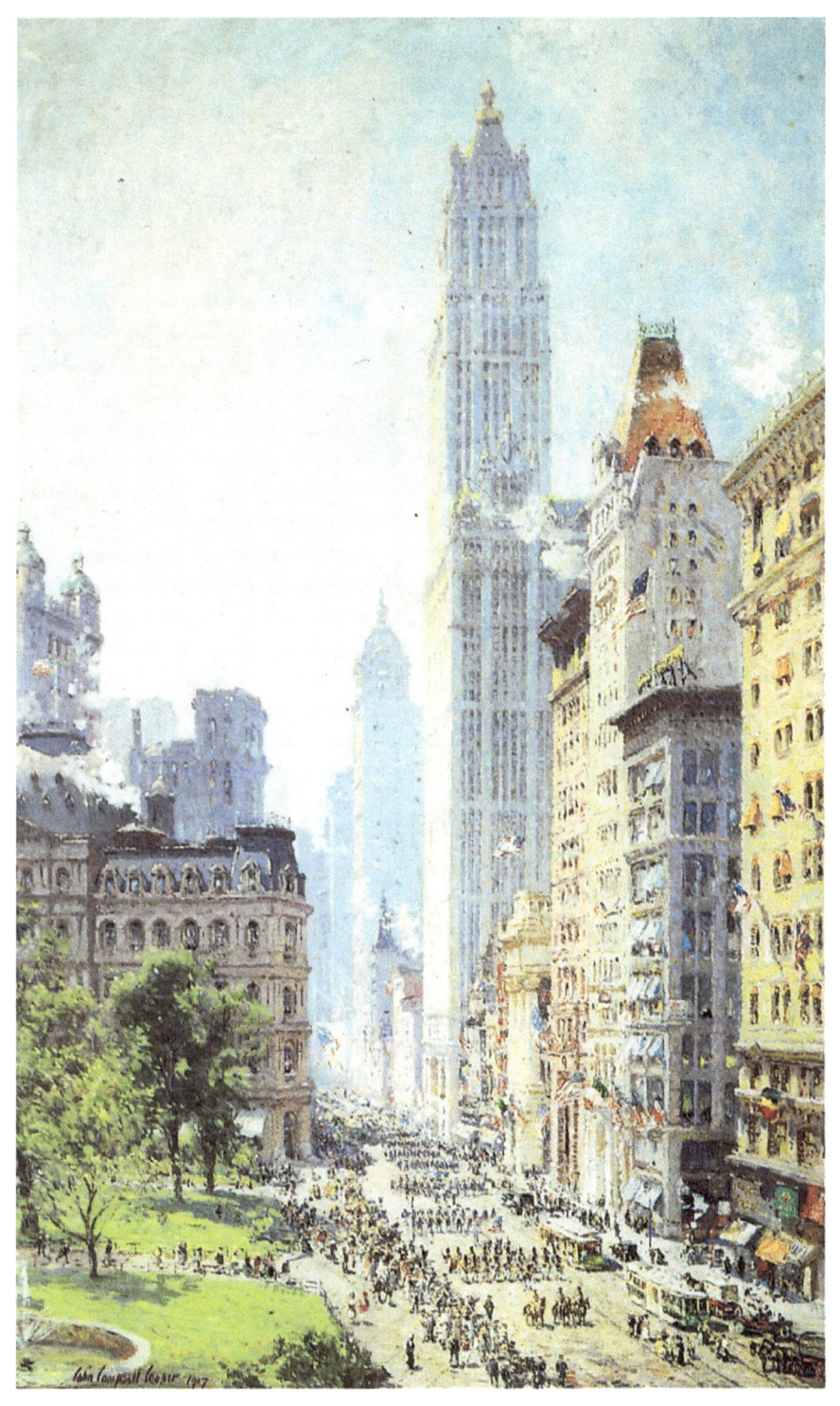

Lower Broadway in Wartime

Colin Campbell Cooper, 1917

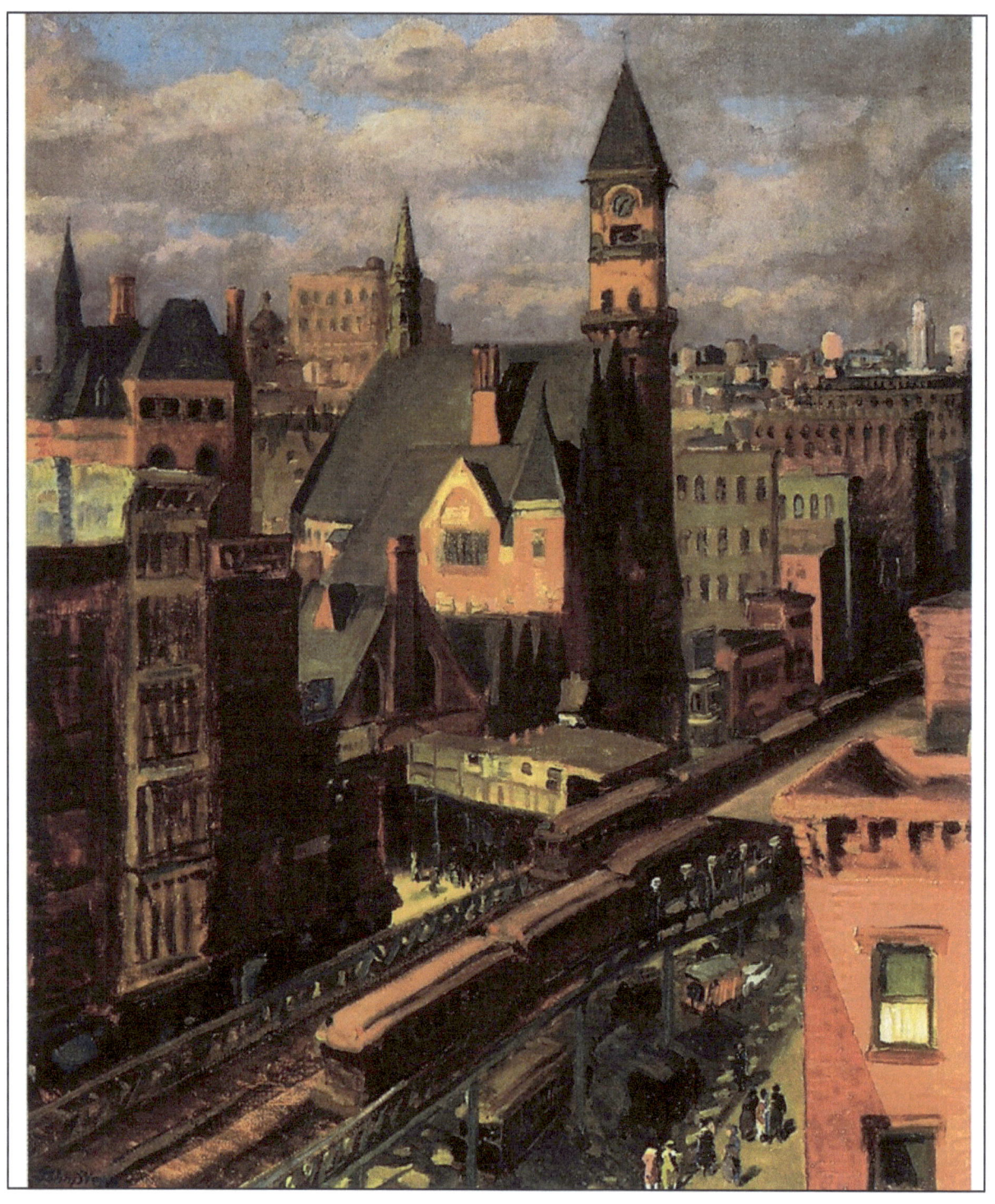

Jefferson Market, Sixth Avenue

John Sloan, 1917

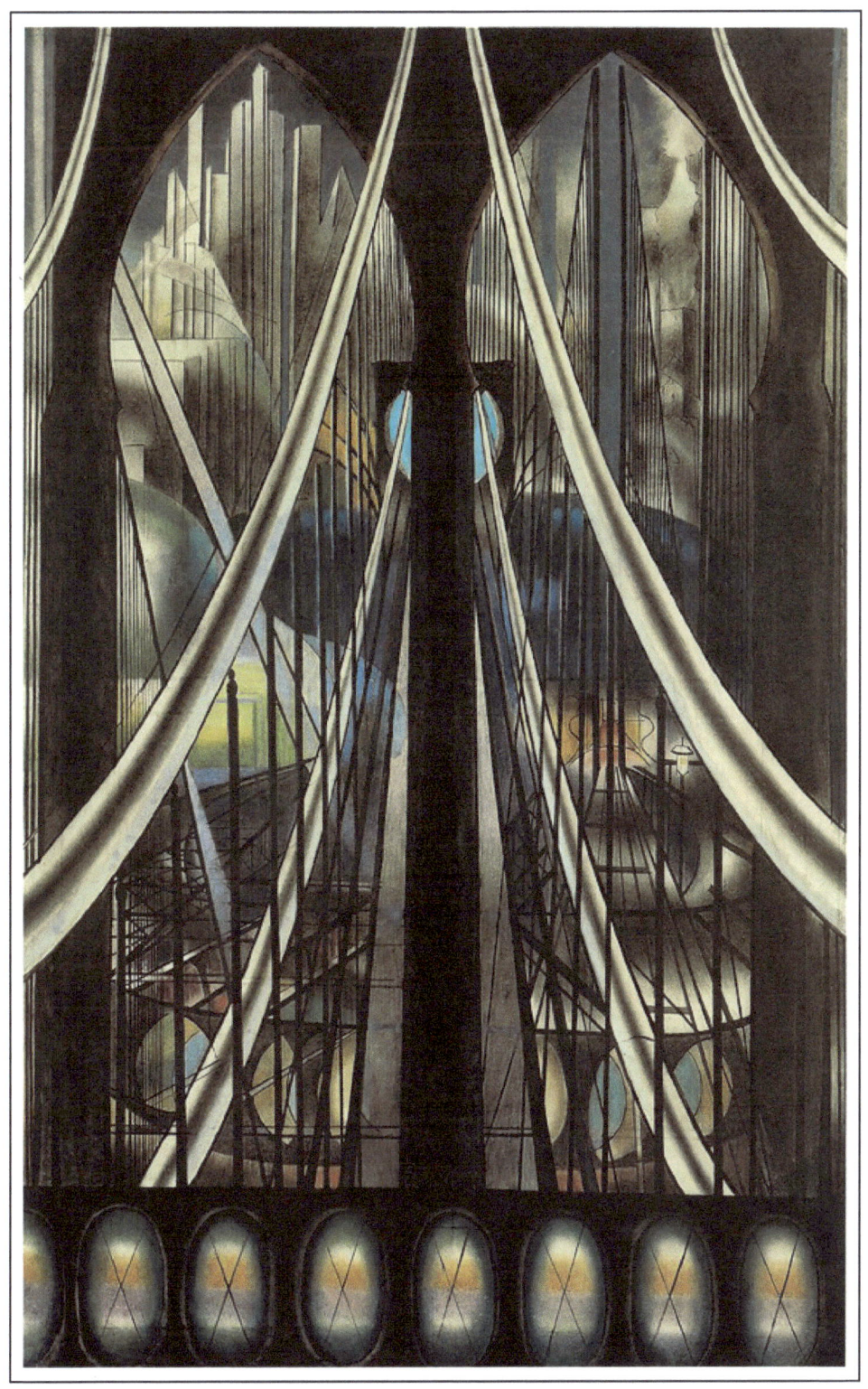

The Brooklyn Bridge

Joseph Stella, 1922

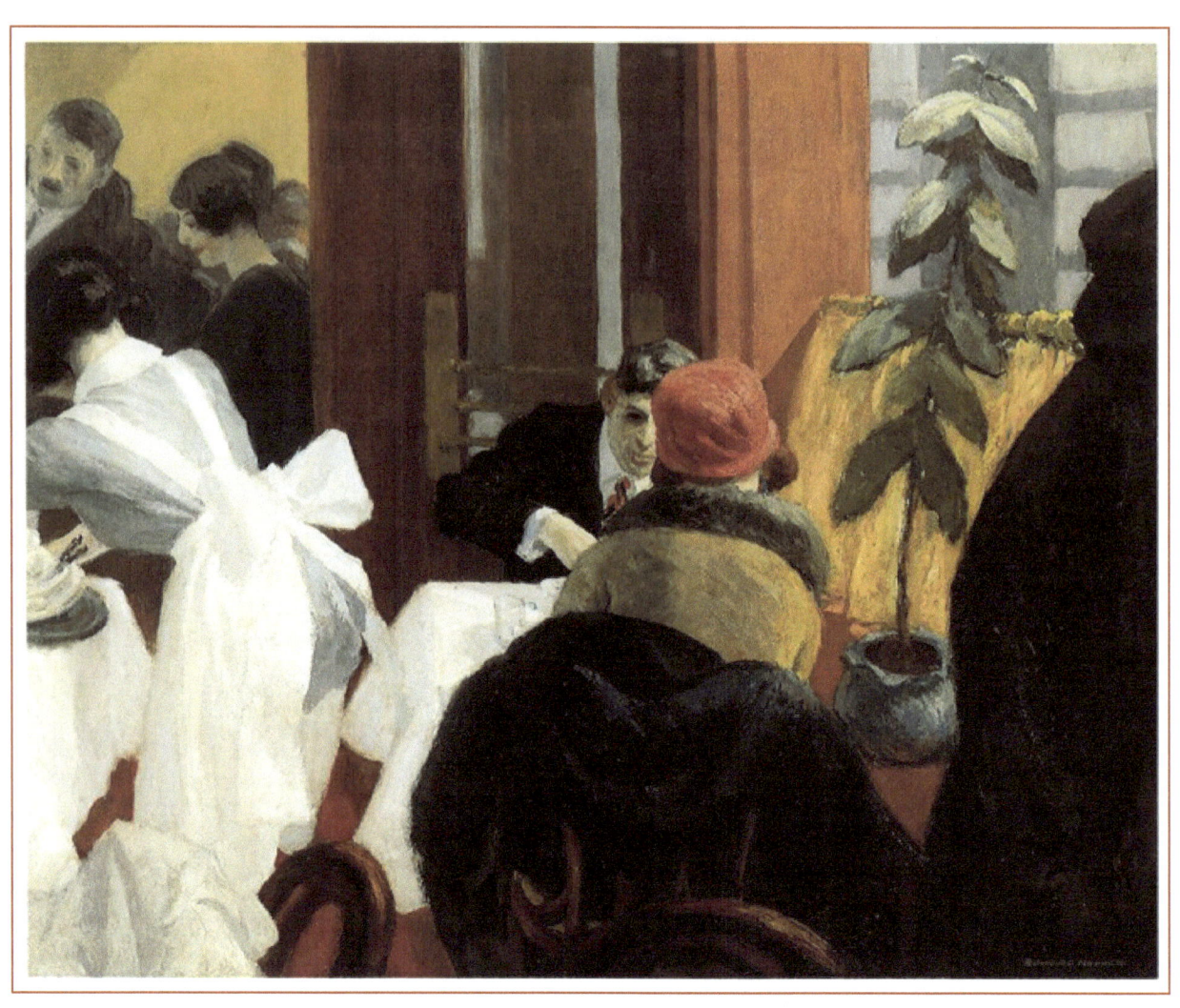

New York Restaurant

Edward Hopper, 1922

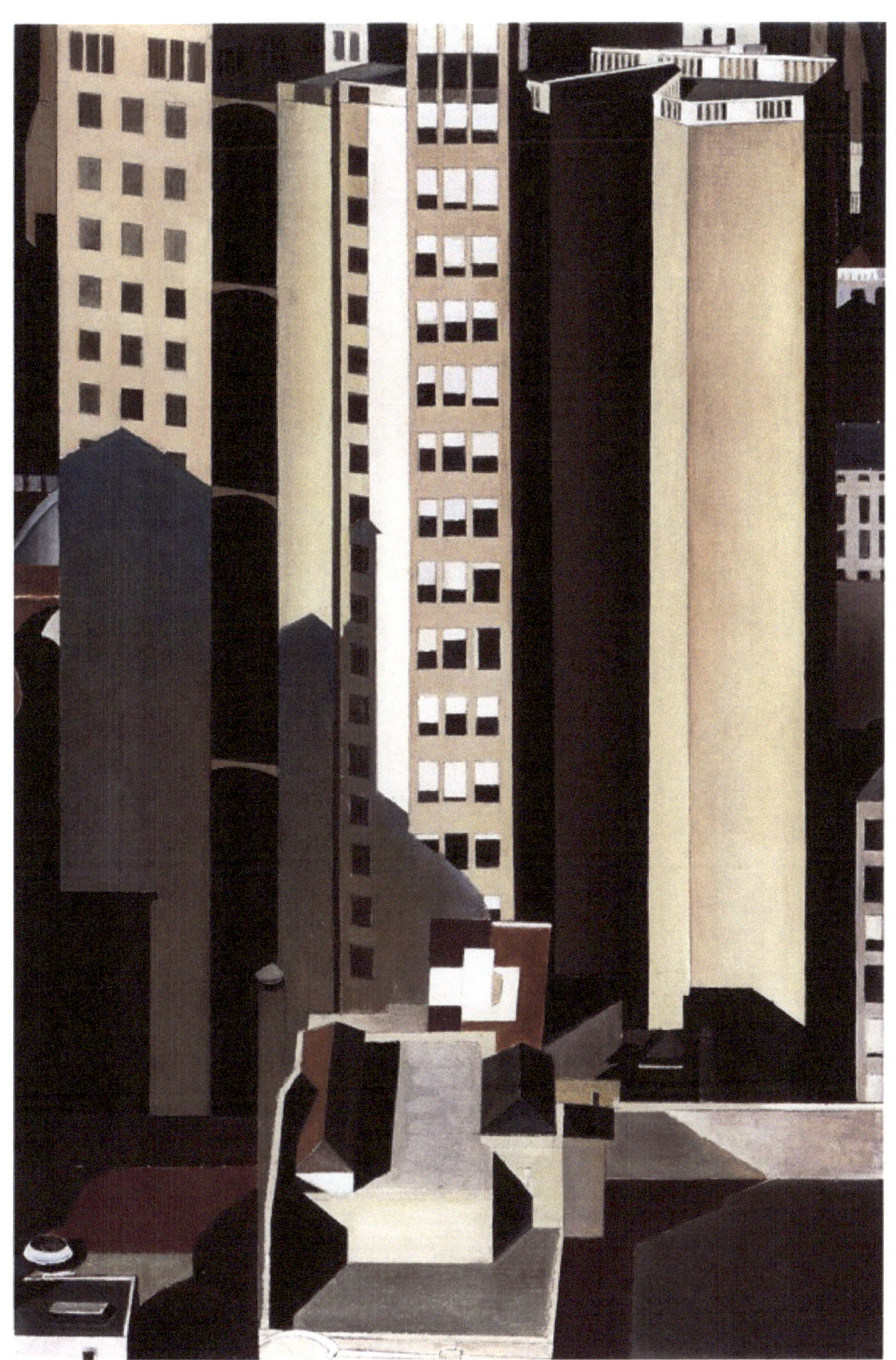

Skyscrapers

Charles Sheeler, 1922

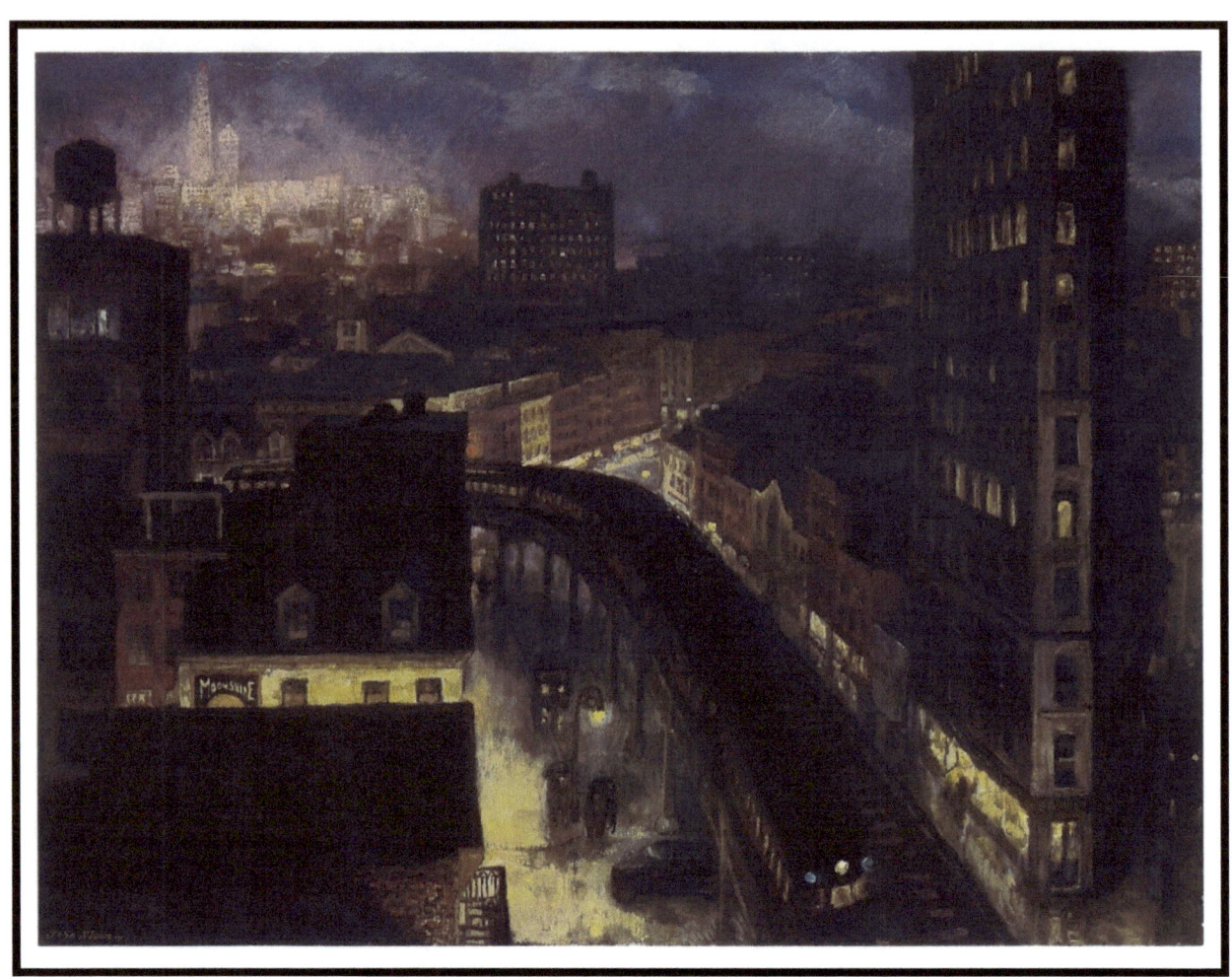

The City from Greenwich Village

John Sloan, 1922

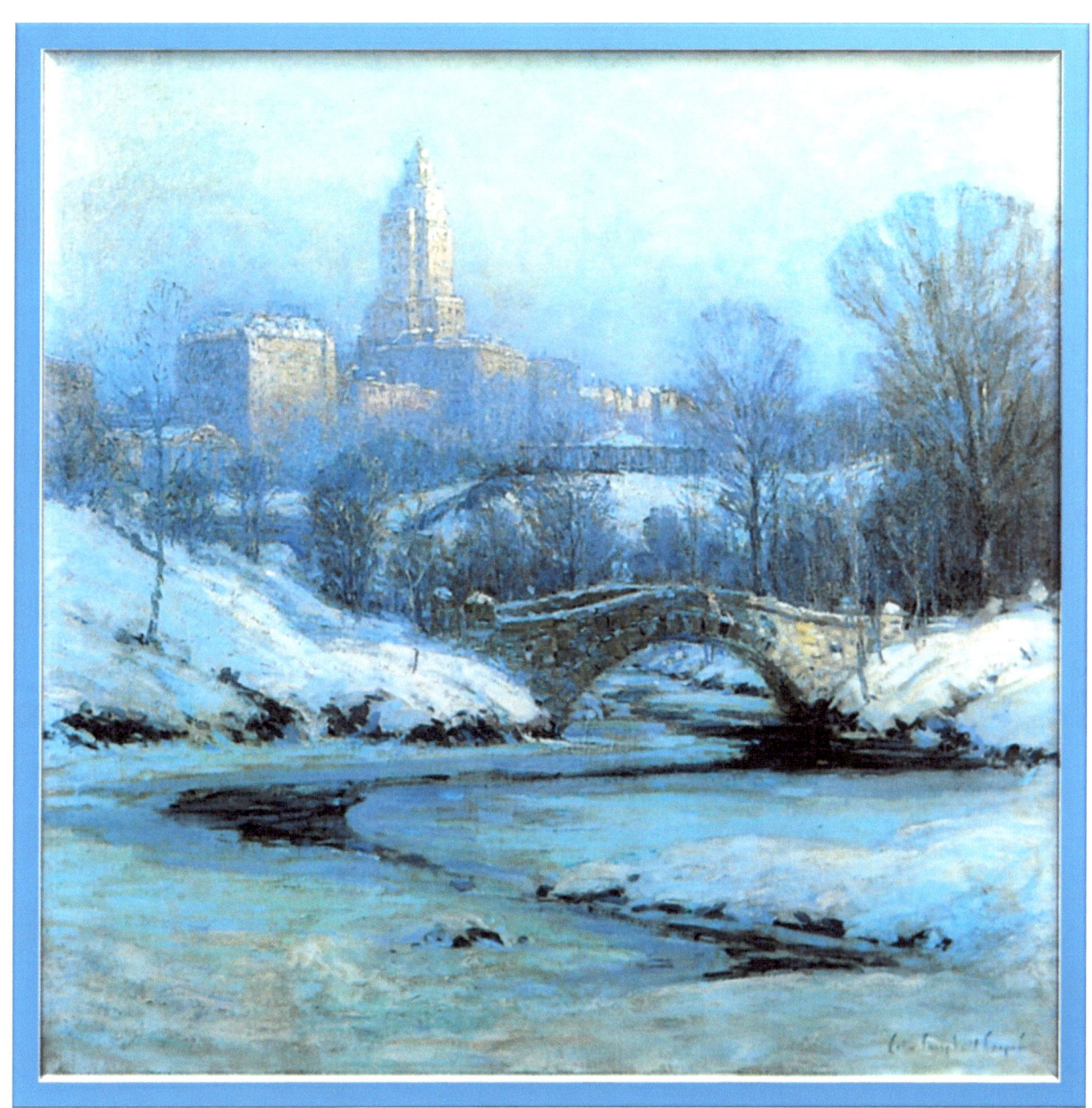

Central Park

Colin Campbell Cooper, 1927 – 1931

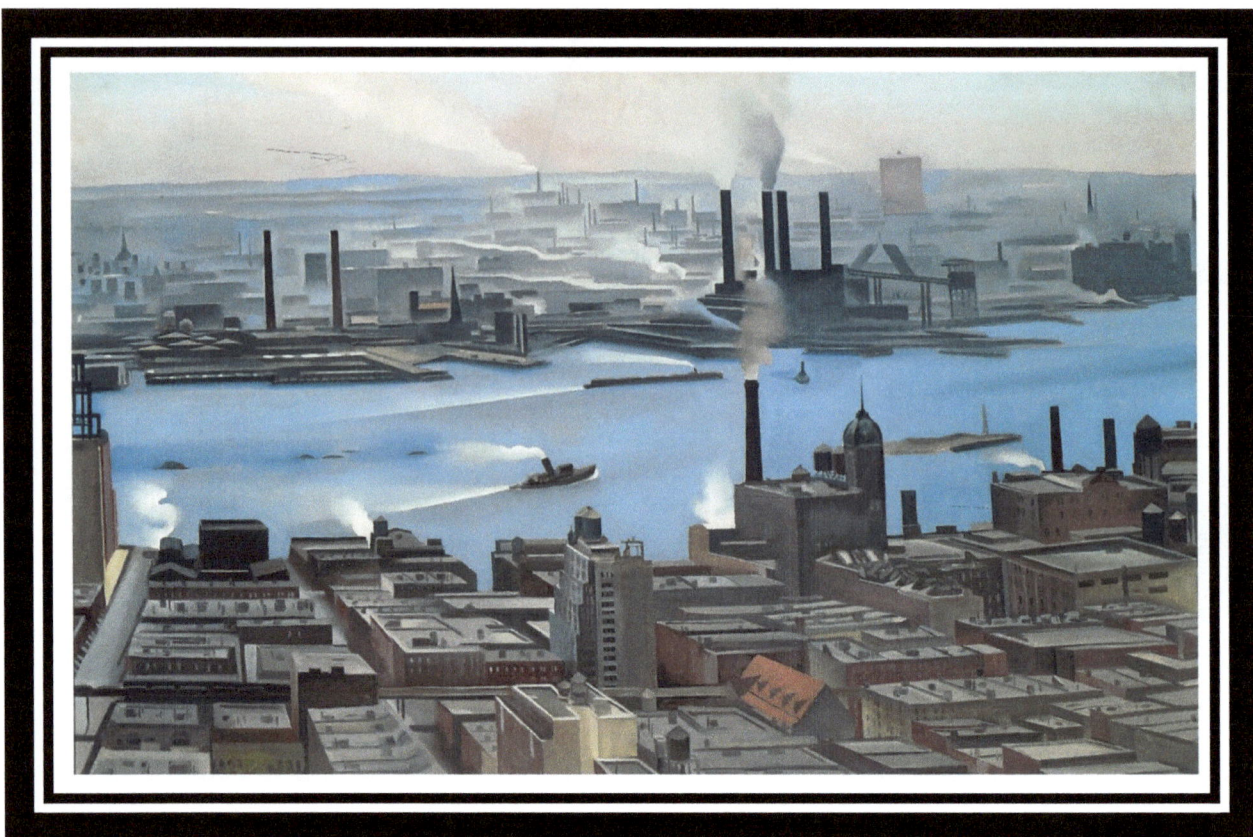

East River from the 30th Story of the Shelton Hotel

Georgia O'Keeffe, 1928

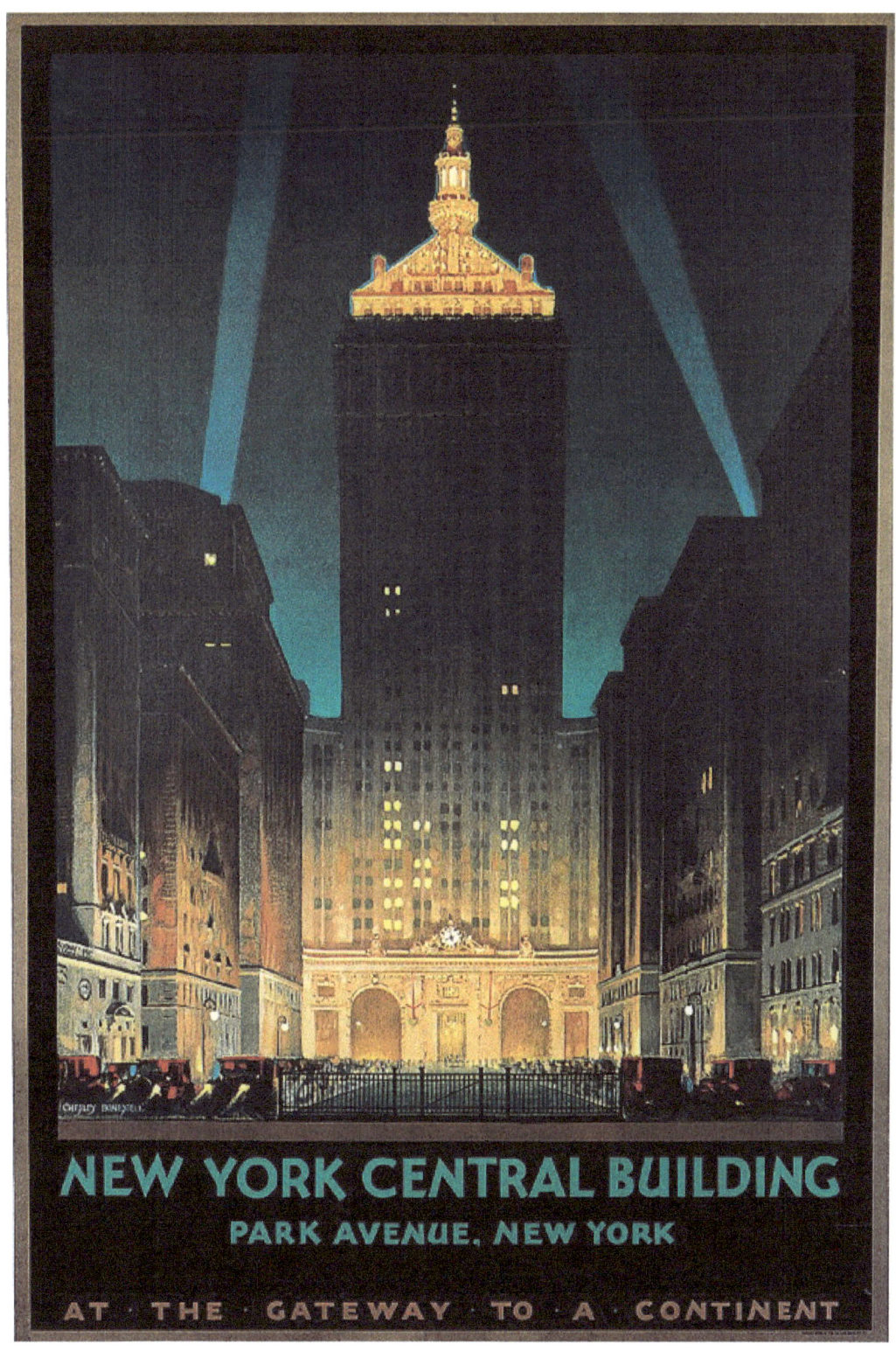

New York Central Building

Chesley Bonestell, 1930

www.ingramcontent.com/pod-product-compliance
Lightning Source LLC
Chambersburg PA
CBHW040753200526
45159CB00025B/2081